THE ART OF
Paint Pouring
SWIPE, SWIRL & SPIN

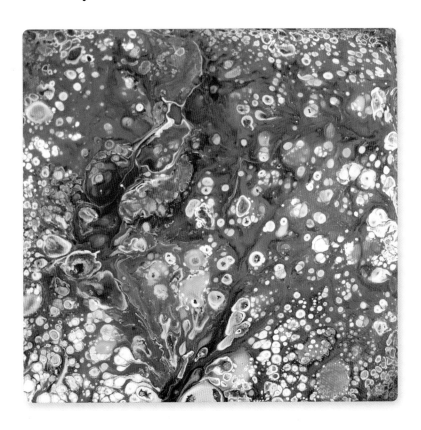

Amanda VanEver

Walter Foster

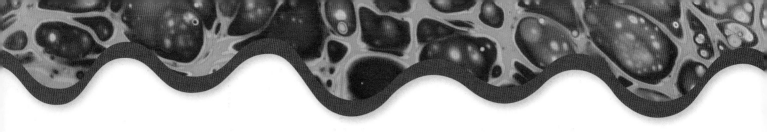

First published in 2020 by Walter Foster Publishing, an imprint of The Quarto Group.
100 Cummings Center, Suite 265D, Beverly, MA 01915, USA.
T (978) 282-9590 F (978) 283-2742 **www.quarto.com** • **www.walterfoster.com**

ISBN: 978-1-63322-824-5

Digital edition published in 2020
eISBN: 978-1-63322-825-2

In-House Editor: Annika Geiger

Printed in China
10 9 8 7 6 5 4 3

Table of Contents

INTRODUCTION . 4
TOOLS & MATERIALS . 6
COLOR BASICS .14
PREPARING TO PAINT .19
MIXING PAINT . 20
CREATING CELLS . 26
FINISHING ARTWORK . 28
SAVING LEFTOVER PAINT . 36
STEP-BY-STEP PROJECTS . 38
 Dirty Pour . 40
 Flip Cup . 46
 Flip & Drag . 52
 Straw-Blown Paint . 58
 Variation: Hair Dryer-Blown Paint 62
 Dip . 64
 Variation: Glove Dip . 70
 Tree Ring . 72
 Variation: Wandering Tree Ring 78
 Spinning Pour . 82
 Sink-Strainer Pour . 88
 String Pull . 94
 Variation: Feather String Pull 100
 Negative Space . 102
 Swipe . 108
 Embellishing Art . 114
 Jewelry & Bookmarks 118
 Coasters . 120
INSPIRATION GALLERY .126
ABOUT THE ARTIST .128

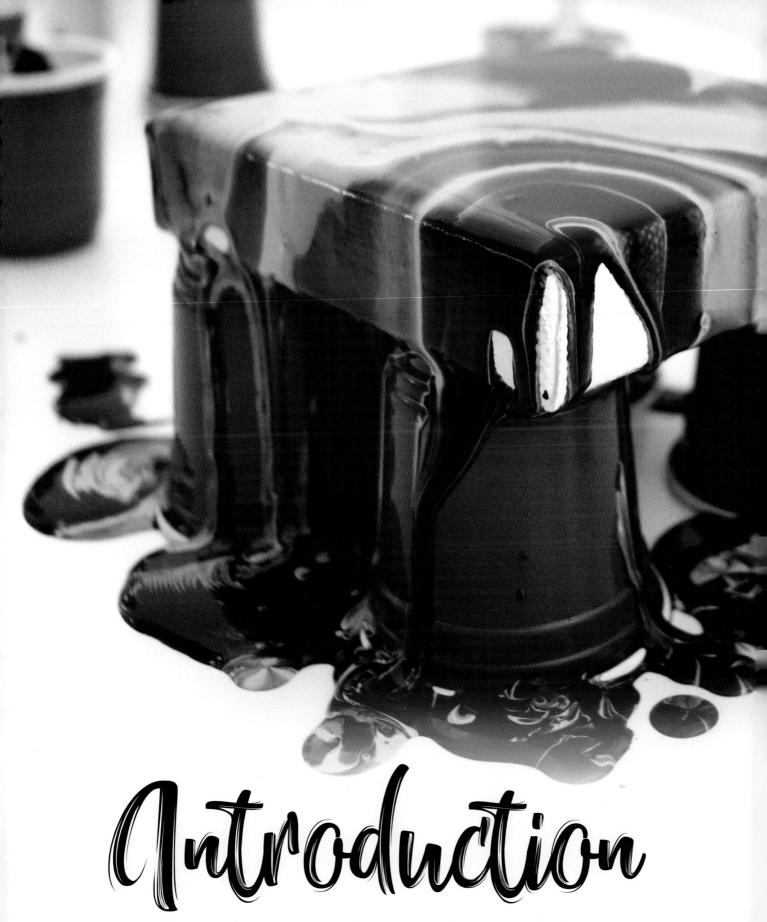

Introduction

I've been painting with fluid acrylics for more than two years, and I cannot believe where my journey has taken me. I have learned so many fun and interesting techniques, and I have been able to express myself in ways that I never thought possible.

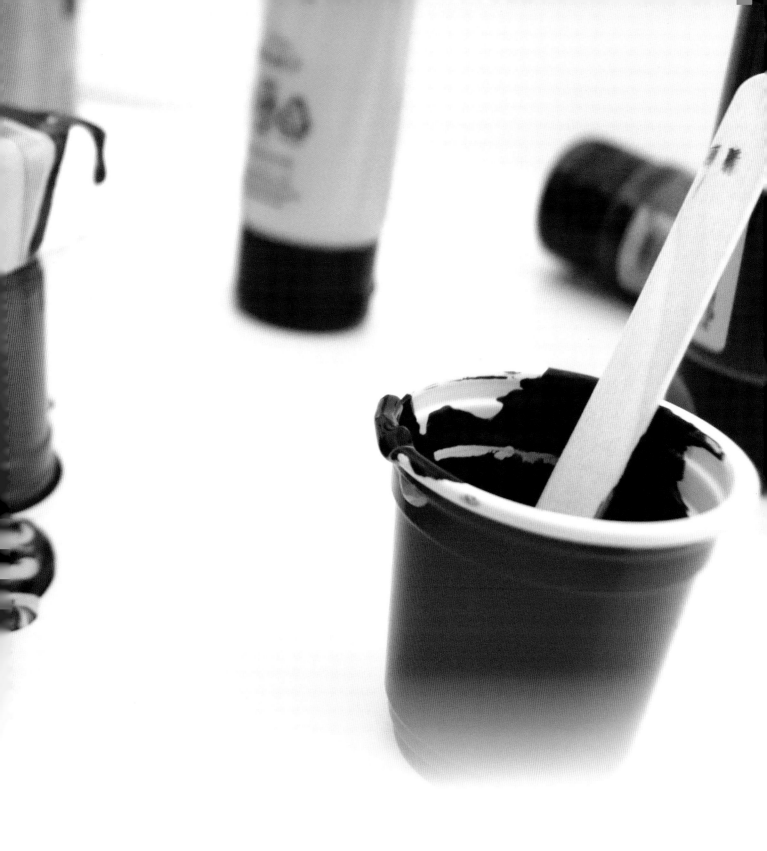

Anyone can do this type of art, and with the variety of paints, pouring mediums, and techniques available, you have countless sources of inspiration with which to create your own artwork. This book features beginning to more advanced paint-pouring techniques, and I hope the projects and tutorials inspire you on your own fluid art journey. I have provided suggested supplies and techniques that I enjoy, but this book is not a complete list of techniques or supplies—just a starting point to help you learn how to start paint pouring. Let's begin!

Tools & Materials

Here are the most popular supplies used to create poured art and where to find them.

PAINTING SURFACES

CANVAS I use canvas or wood for most of the techniques demonstrated in this book. Canvas can be found online and in any craft store.

IF YOUR CANVAS SAGS IN THE MIDDLE, SPRITZ THE BACK WITH WATER AND LET IT DRY TO TIGHTEN UP THE CANVAS.

WOOD In addition to canvas, I also enjoy painting on wood surfaces. I find wood surfaces online, in craft stores, and at home-improvement stores. I like wood surfaces for their sturdiness and the large variety of shapes and sizes that they come in. You can use basic shapes like circles or squares, or find special shapes ranging from holiday-themed pieces to letters and numbers.

DUE TO THE AMOUNT OF MOISTURE ADDED TO THE PAINT MIXTURE, YOU MAY WANT TO PRIME OR GESSO YOUR WOOD PIECES BEFORE USE TO KEEP THEM FROM WARPING.

OTHER SURFACES Canvas and wood are just two examples of the surfaces you can use for paint pouring. I also use watercolor or YUPO® (waterproof, synthetic) paper to make bookmarks, greeting cards, jewelry, and hair clips, and I've poured on Christmas ornaments, clay pots, glass vases, and even furniture. So many household items can be used as surfaces for fluid art!

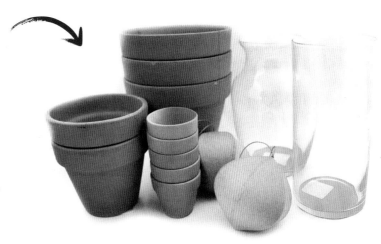

ONE THING I LOVE ABOUT THIS TECHNIQUE IS THE WIDE VARIETY OF ITEMS THAT YOU CAN PAINT AND DECORATE.

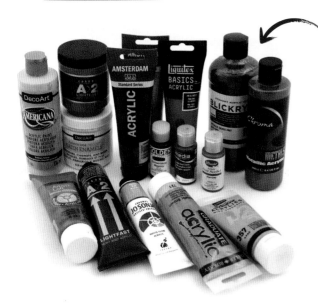

PAINT

I use acrylic paints. There are many brands to choose from; you can use whatever is available in your area, at craft stores, and online.

I LIKE TO USE ACRYLIC PAINTS, BUT OTHER MEDIUMS, INCLUDING ACRYLIC INKS AND GEL STAINS, CAN BE USED AS WELL. A LOT OF MY LEARNING COMES THROUGH TRIAL AND ERROR. TRY VARIOUS PAINTS AND MEDIUMS TO SEE HOW THEY TURN OUT.

Paint tubes and jars feature a lot of useful information. Each brand has its own method or representation of brand name, color name, color swatch, batch number, paint amount, opacity, and lightfastness.

OPACITY The opacity of a paint determines how much coverage that paint will provide. The more transparent the paint, the less it covers. Each brand labels its paint according to opacity, and you can use this information when choosing colors to use in your paint pouring.

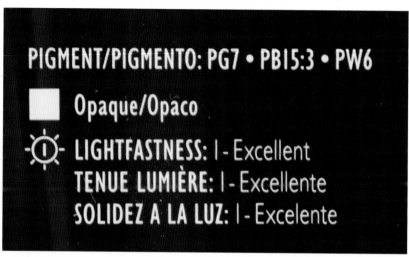

PIGMENT/PIGMENTO: PG7 • PB15:3 • PW6

Opaque/Opaco

LIGHTFASTNESS: I - Excellent
TENUE LUMIÈRE: I - Excellente
SOLIDEZ A LA LUZ: I - Excelente

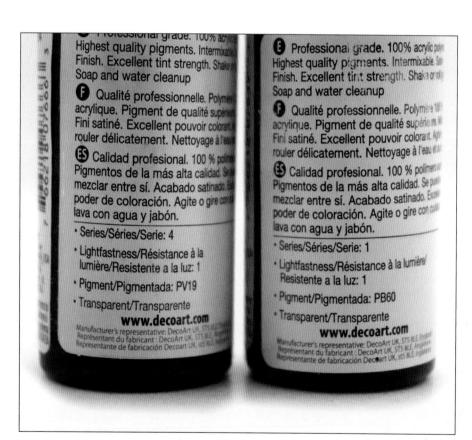

LIGHTFASTNESS The lightfastness of a paint is a factor in the quality of your finished painting. Lightfast paint will not discolor or fade over time when exposed to light. The purpose of your painting (whether you are painting for fun and practice or a professional piece to sell) will help determine the quality of paint you want to use. If you are practicing, you can use less expensive craft paints or student-grade paints. If you are working on a more professional piece, you may want to use artist-grade paints so that your colors will stay bold and vibrant over time.

POURING MEDIUMS

Pouring mediums, which can be found online and in craft stores, are added to paint to create a thinner, more fluid paint used for poured artwork. Self-leveling and helpful for creating even coverage on your canvas, they can also reduce the appearance of brushstrokes if you use a paintbrush or palette knife in your work. In addition, they can make the paint take longer to dry, which extends the amount of time you have to work with your fluid art.

Mixing too much water with your paint can cause the acrylic bonds to break, and over time, your painting may crack or flake, ruining your art. Pouring mediums keep those acrylic bonds intact.

In this book, I use a variety of pouring mediums so that you can see examples of the available mediums and how each one dries.

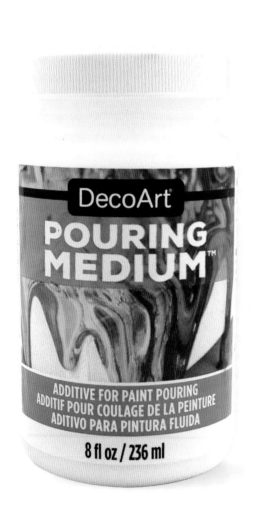

PAINT CONDITIONERS OR PAINT EXTENDERS

Paint conditioners or paint extenders can be found in home-improvement stores. They are mostly used with house paint, but they can also be added to acrylics to create the right consistency for pouring without breaking the paint bonds. Like pouring mediums, paint extenders help create a smooth, level finish while extending the amount of time you have to work with your paint.

GLUE Craft and home-improvement stores carry a variety of glue types that can be used instead of or in addition to other pouring mediums.

YOU CAN USE DIFFERENT RATIOS OF POURING MEDIUM, GLUE, AND WATER TO CREATE THE THICKNESS THAT YOU PREFER FOR PAINT POURING.

ADDITIVES

One popular element of fluid art is the cells you often see in poured pieces. Cells can form naturally, but many household products can also be added to paint to promote the creation of cells. Liquid silicone and dimethicone (makeup-grade liquid silicone) are the most commonly used products to create cells.

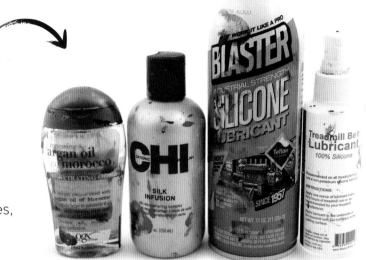

Online retailers, home-improvement stores, craft stores, and even grocery stores all carry products containing silicone or dimethicone. When looking for a product that includes silicone or dimethicone, ensure that one is in the top two or three products on the list of ingredients. I like to use hair serums that contain dimethicone as well as 100-percent liquid silicone used for treadmill lubricant.

USE ONLY LIQUID SILICONE FOR PAINT POURING; SILICONE CAULK WILL NOT WORK.

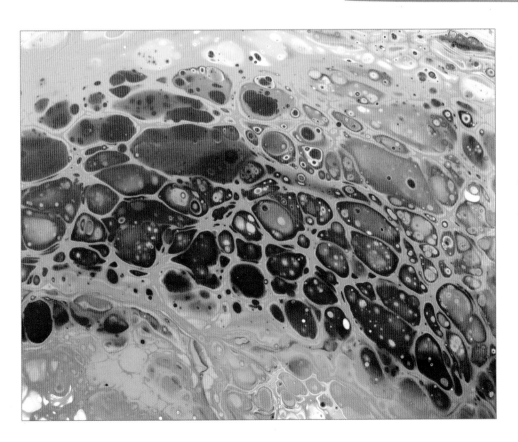

I created the cells in this piece by adding 100-percent liquid silicone to my paint mixture.

ADDITIONAL ESSENTIAL ITEMS

- Cups to mix and pour paint
- Wooden stir sticks to mix paint
- Gloves and a respirator for protection from harmful fumes and skin irritants
- A kitchen torch to help create cells
- Tape for the back of the painting (to keep it clean or for finishing; see page 19)
- Paper towels for cleanup
- Freezer paper to catch extra paint
- Paper or silicone baking mats to save leftover paint

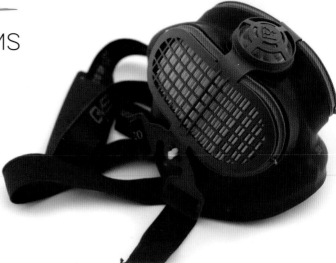

REUSABLE MATERIALS

If you like to reuse or recycle your art materials, you can let the paint dry in cups and peel out the dried paint to reuse the cups. I have also used lunch-meat containers, yogurt cups, margarine or butter containers, glass jars, and condiment bottles to pour and store paint. Don't forget to check out secondhand stores, dollar stores, and garage sales to find supplies to use or reuse in your pouring.

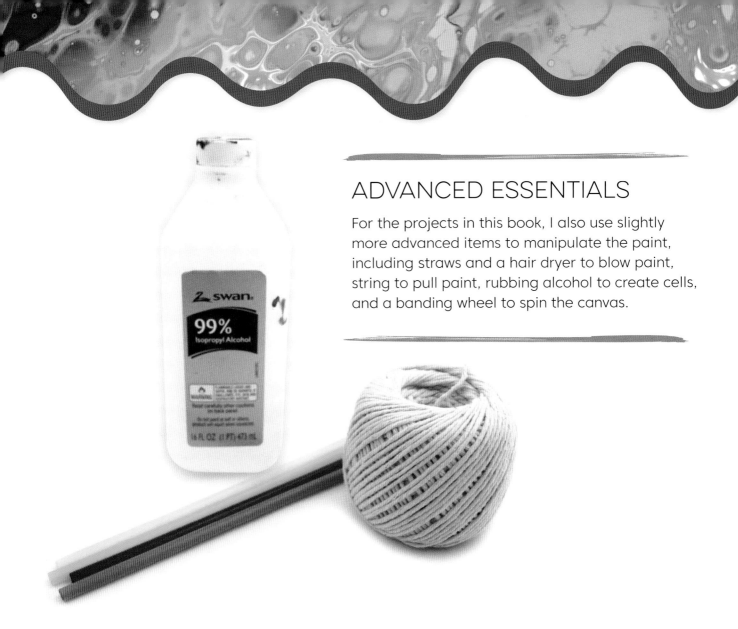

ADVANCED ESSENTIALS

For the projects in this book, I also use slightly more advanced items to manipulate the paint, including straws and a hair dryer to blow paint, string to pull paint, rubbing alcohol to create cells, and a banding wheel to spin the canvas.

 SAFETY FIRST

I use some materials in ways that are not intended by the manufacturer.* Some items used can have harmful fumes and may cause eye or skin irritations. Always wear protective gear like gloves, goggles, and a respirator. Keep a fire extinguisher near your work area, and make sure the area is well ventilated.

Here are a few additional safety tips:

- Use soap and water to remove acrylic paint from your skin.
- Use rubbing alcohol to remove resin from your skin.
- Review all instructions and manufacturer warnings before using any of these products.

*The publisher and author assume no responsibility or liability for damages or injuries that may result from the use of the materials and/or techniques demonstrated in this book.

Color Basics

Understanding basic color theory is important no matter what kind of art you create. Color plays a significant role in the overall mood or feeling of a painting, as colors can elicit various emotions in viewers.

Knowing how colors mix and interact with each other will help you choose the ideal color palettes for your poured paintings.

COLOR WHEEL

The color wheel is used to demonstrate the relationships between colors.

RED

PURPLE

ORANGE

BLUE

GREEN

YELLOW

PRIMARY, SECONDARY & TERTIARY COLORS

The primary colors are red, yellow, and blue. They are the basis for all other colors on the color wheel and cannot be created by mixing other colors. By mixing the primary colors in various combinations, you can create the secondary colors: green, orange, and purple. These colors complement each other and do not turn muddy.

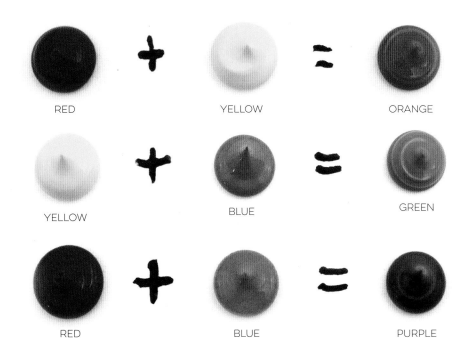

RED + YELLOW = ORANGE

YELLOW + BLUE = GREEN

RED + BLUE = PURPLE

Mix primary and secondary colors to create tertiary colors, or the in-between colors like yellow-orange, yellow-green, blue-green, red-purple, and blue-purple.

Mixing secondary colors can create muddy-looking combinations. When selecting paint for pouring, you'll want to keep this in mind. I do mix some secondary colors, but if the paint is overmixed or too thin, the final piece can turn muddy and you may lose your original colors.

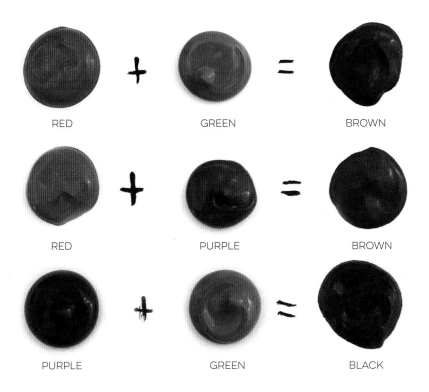

RED + GREEN = BROWN

RED + PURPLE = BROWN

PURPLE + GREEN = BLACK

SAMPLE COLOR PALETTES

I paint with a wide variety of color palettes, and here I've listed some of my favorites. Many of them include a metallic shade; I love the pop of color and shimmer that metallics give to a finished piece!

Remember that these are just suggestions. Feel free to mix and match your own color palettes, and try mixing paints to create your own shades as well.

BLACK, WHITE, AND COPPER

WHITE, PHTHALO GREEN, AND GOLD

RED, ORANGE, YELLOW, GREEN, TURQUOISE, BLUE, AND PURPLE

BLACK, NEON PINK, NEON PURPLE, NEON ORANGE, NEON YELLOW, AND NEON GREEN

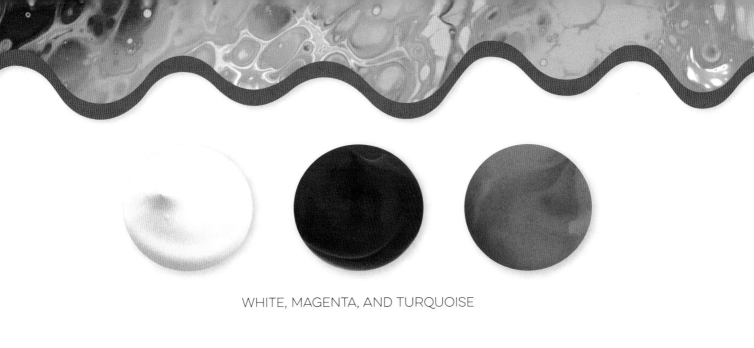

WHITE, MAGENTA, AND TURQUOISE

ROSE GOLD, PURPLE, AND WHITE

PRUSSIAN BLUE, TURQUOISE, WHITE, AND COPPER

MAGENTA, TURQUOISE, RED GOLD, YELLOW, AND WHITE

PRUSSIAN BLUE, PEWTER, AND WHITE

BLACK, GOLD, AND TURQUOISE

BROWN, BEIGE, WHITE, AND ROSE GOLD

WHITE, ORANGE, MAGENTA, AND PURPLE

Preparing to Paint

Before I begin painting, there are a few things I always like to do.

First, I place something over my working surface to protect the table and to catch any leftover paint. The shiny side of freezer paper works well for this purpose, but you can also use a plastic bag, newspaper, a disposable tablecloth, a washing machine drip tray, or a shallow plastic storage bin.

To keep the back of my canvas clean, I place tape on it before painting. Painter's tape works well, as it adheres to the canvas but can be removed easily without damaging the painting.

Place strips of tape around the canvas edges; then use scissors to remove the excess tape. Tape will keep the bottom of your canvas protected if any paint drips underneath during pouring.

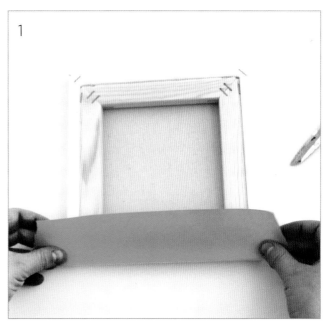

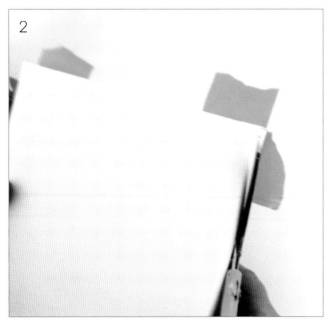

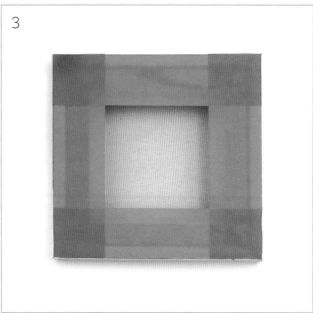

Mixing Paint

Mixing paint with water and pouring medium is an important step in the paint-pouring process. It can take a bit of practice to get the consistency right every time you pour, however. Moreover, I find that I prefer different consistencies depending on the technique I'm using. For some techniques, I keep my paint mixtures thicker so that the colors won't blend. If I want my colors to blend, I make the paint thinner.

As part of your learning process, try pouring with paint that is thinner or thicker than what you would normally use and see how the results turn out. From there, you can practice and tweak your paint mixture until you're happy with it.

IF LUMPS FORM AFTER YOU'VE MIXED THE PAINT AND THE POURING MEDIUM, DON'T ADD WATER. KEEP MIXING UNTIL THE LUMPS DISAPPEAR. ADDING WATER TOO SOON WILL MAKE IT MORE DIFFICULT TO WORK OUT THE LUMPS OF PAINT.

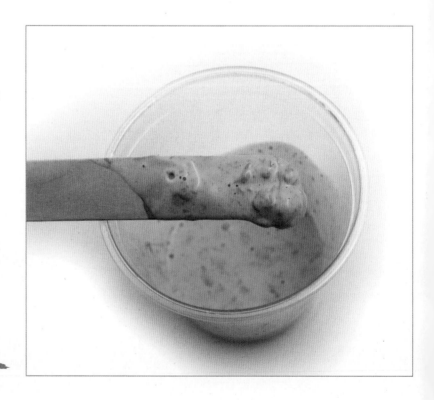

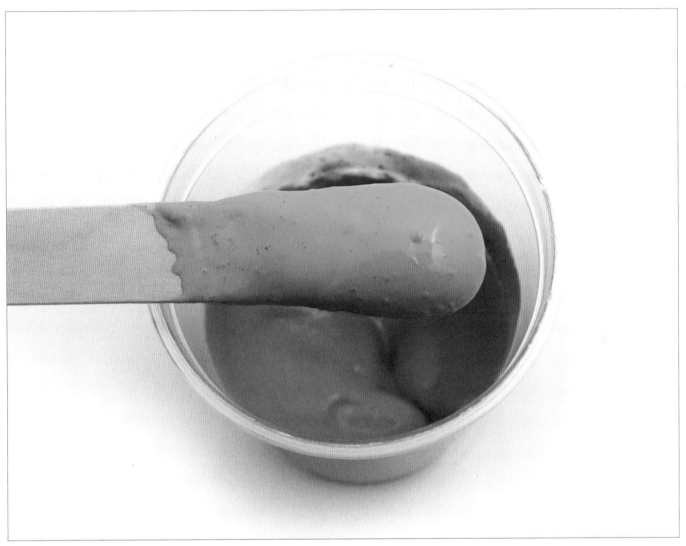

IF YOU ACCIDENTALLY ADD TOO MUCH WATER TO YOUR PAINT MIXTURE AND CREATE A THINNER CONSISTENCY THAN YOU'D LIKE, ADD MORE PAINT AND POURING MEDIUM UNTIL THE MIXTURE REACHES YOUR DESIRED CONSISTENCY.

When mixing paint, many artists prefer a consistency similar to warm honey or heavy cream. If the paint is too thick, it won't move well across the canvas; if it's too thin, the colors will blend too much and can turn muddy.

TYPES OF PAINT & MIXING PROPERTIES

I briefly mentioned paint on pages 7-8, but now let's discuss it in more detail. I'll go over the benefits and drawbacks of various types of paint, as well as the effects and techniques you can create with each type.

HEAVY-BODY ACRYLIC PAINTS A professional grade of acrylic paint with a consistency similar to oil paint, heavy-body paints can be used to create texture or an impasto effect (see below). You can mix heavy-body paints with any pouring medium, but because of their dense viscosity, it may take more time to mix and work out the lumps to create a consistency that's suitable for pouring.

THE IMPASTO TECHNIQUE FEATURES A LAYER OF PAINT THICK ENOUGH TO ALLOW BRUSHSTROKES AND PALETTE KNIFE STROKES TO REMAIN VISIBLE.

MEDIUM-BODY ACRYLIC PAINTS These student-grade, economically friendly paints are great when you want to practice pouring, and there are many brands from which to choose. They feature a smooth viscosity, can be mixed with any pouring medium, and are easier to mix to the correct pouring consistency than heavy-body paints.

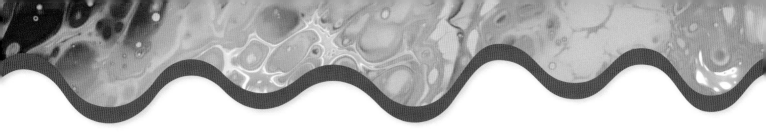

SOFT-BODY ACRYLIC PAINTS With a smooth consistency and a large pigment load, soft-body paints can be mixed into pouring mediums without forming lumps, and you only need a small amount of paint.

FLUID ACRYLICS With a much thinner consistency than heavy-, medium-, or soft-body paints, fluid acrylics are designed to flow effortlessly, making them ideal for paint pouring. They also contain a large pigment load, so you only need a small amount to create bold, vibrant artwork.

ACRYLIC INKS A fluid, acrylic-based medium, these inks can be added to any pouring medium and used in the same way as regular acrylic paints. Because their pigment is very fine and they dry water-resistant, inks can also be used in airbrushing, for stamping, and on fabric. They are great for adding embellishments, writing, or silhouettes to poured artwork.

CRAFT PAINTS Like student-grade acrylics, craft paints are affordable, but they do contain less pigment than student- and professional-grade paints. One benefit to craft paints is that they come in a wide variety of colors, so you don't have to mix your own shades. They also have a more fluid consistency and require only a small amount of water or medium for pouring. Craft paints come in a variety of finishes, including matte, satin, gloss, metallic, chalk, and outdoor quality.

MIXING RATIOS

My own mixing ratio comes from trial and error. After lots of practice, I've found that mixing 1 part paint with 2 parts pouring medium works well for most techniques.

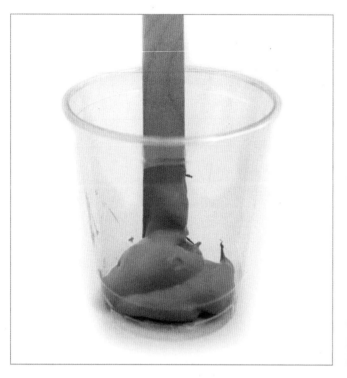 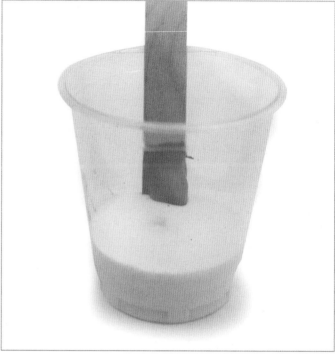

When working with soft-body paints and fluid acrylics, which have a heavy pigment load, make sure you read the mixing instructions on the container of paint, as you will need a ratio of about 1 part paint to 9 parts pouring medium. When mixing fluid acrylics with pouring medium, you may not need to add water.

IF THE PAINT MIXTURE SEEMS TOO THICK, SLOWLY INCORPORATE WATER UNTIL THE CONSISTENCY IS RIGHT FOR POURING.

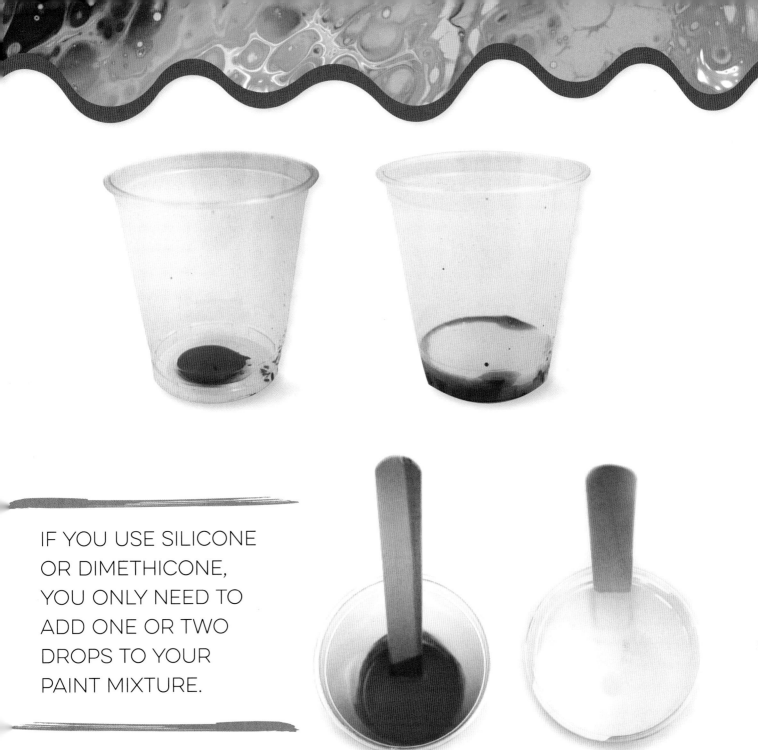

IF YOU USE SILICONE OR DIMETHICONE, YOU ONLY NEED TO ADD ONE OR TWO DROPS TO YOUR PAINT MIXTURE.

HOW TO MIX PAINT FOR POURING

1. Pour your paint.

2. For 1 ounce of paint, add about 2 ounces of pouring medium.

3. Mix the pouring medium into the paint.

4. Slowly add water and mix until the paint mixture reaches the consistency that you want for pouring.

5. If you are using silicone or dimethicone to create cells (see pages 26-27), you only need to add one or two drops to your paint mixture.

Creating Cells

The bubbles and patterns you see in poured artwork are called "cells." You can use a few products to create cells, including liquid silicone or dimethicone, which is what we'll focus on in this book.

SILICONE & DIMETHICONE

One way to create cells—and in my opinion the easiest—is with liquid silicone or dimethicone. These are included in many household and cosmetic products and are easy to find in stores and online. Dimethicone can be found in hair oils and serums, and 100-percent liquid silicone is used for car maintenance and home improvement and repairs. Check the list of ingredients on a product, and make sure silicone or dimethicone ranks in the top two or three.

You only need to mix one or two drops of silicone or dimethicone into your paint mixture. If you add too much, the paint may pull away from the canvas and form craters. Once the silicone or dimethicone is added to the paint mixture, use any pouring method you like. If you wish, you can then apply a kitchen torch before or after tilting the canvas. Using a torch to heat the paint causes the silicone or dimethicone to react with the paint, which forms the cell structure commonly seen in fluid art.

MAKE SURE TO USE LIQUID SILICONE; SILICONE CAULK WILL NOT WORK.

Liquid silicone products

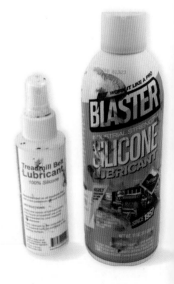

Dimethicone products

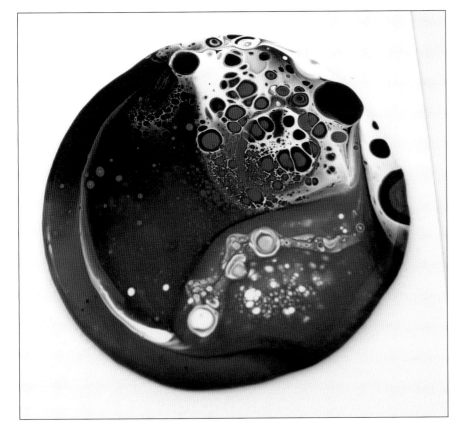

Here I added one drop of silicone to my paint mixture. I used the flip-cup technique (pages 46-51), torched my paint, and then tilted the canvas to create a beautiful, cellular piece.

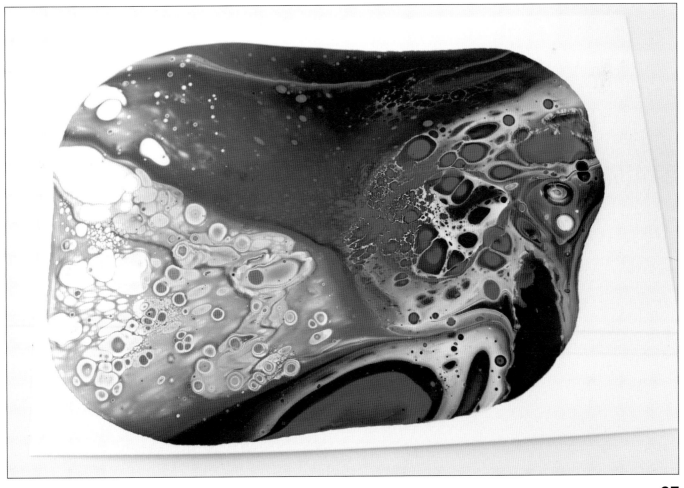

Finishing Artwork

The projects in this book will show you how to use a variety of pouring techniques to create beautiful, original artwork. It's also important to know how to finish and preserve your pieces. Here are some tips and techniques for drying, cleaning, and finishing your fluid art.

DRYING

Throughout this book, I recommend laying paintings on a flat surface to dry. If the surface isn't flat, the design may distort as the paint moves in the direction the canvas tilts. If the canvas tilts too much, the paint can even flow off the edges.

Whether you leave your painting on the cups where you first painted it or move the painting to another location to dry, always check your surface with a level. If the surface is not level, you can place a folded piece of paper under the canvas to even it out.

While drying a painting, you may want to cover it to ensure that no hair and dust land in the wet paint and dry into your painting, especially if you're a pet owner. If you notice the hair while the painting is wet, you can use a toothpick to gently remove the hair (or anything else) that lands in your painting.

If you paint with the windows open or in a garage, insects may also land in your artwork. To prevent this, you can drape a tarp over your table, or grab a large plastic storage container, flip it over, and cover your pieces while they dry.

CLEANING OFF SILICONE

If you used an additive in your paint mixture, such as silicone or dimethicone, you will need to clean it off before finishing your painting with varnish or resin. Otherwise, the silicone residue will repel the varnish or resin and can create pits or craters.

There are various ways to remove silicone. I prefer to use rubbing alcohol and a paper towel, but you can also use a small amount of soap and water, flour, or cornstarch to soak it up.

First, make sure the painting is completely dry. Then, if you're using rubbing alcohol to remove silicone residue, as I like to do, pour the rubbing alcohol on the paper towel.

Gently move the paper towel over the surface of the painting, including the edges. You may see some pigment transfer onto the paper towel, but this shouldn't ruin the painting.

Let the rubbing alcohol evaporate for a couple of hours before using resin or varnish on your piece.

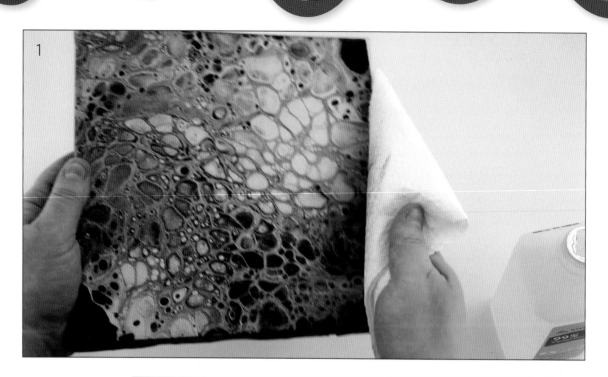

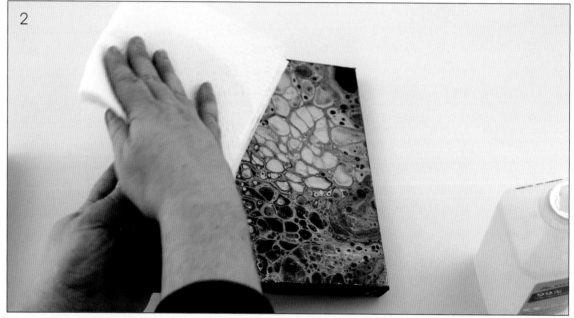

CLEANING TIPS

Another method for cleaning your painting is to dampen a paper towel or washcloth with soapy water and run the paper or cloth over the painting. Then use clean water to wipe down the painting, and let it dry.

Cornstarch or flour can also be used to soak up silicone. Gently dust the surface of your painting with cornstarch or flour and let it sit for 5 to 10 minutes. Use a paintbrush to dust off the painting, and then wipe it down with a damp paper towel to ensure that you've removed all the cornstarch or flour.

FINISHING

Once complete, you can leave your painting as is, or you can add varnish or resin to finish.

Varnish

You can use a couple of types of varnish, including liquid and spray varnishes, to finish and protect your paintings. Varnishes, which are sold online and in craft and home-improvement stores, do not yellow and are water-resistant after drying. Some varnishes are also UV-resistant to protect artwork from sunlight.

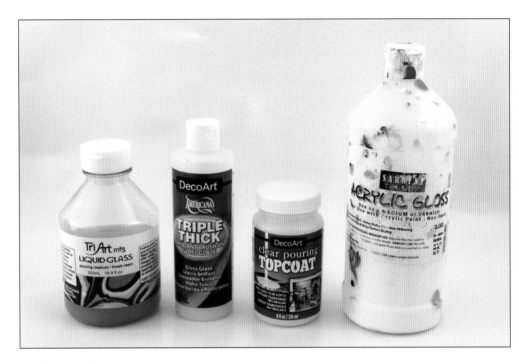

Liquid varnishes

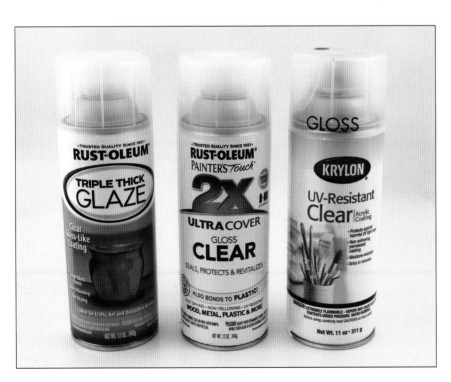

Spray varnishes

Varnishes come with different finish options, including gloss and matte. A gloss varnish creates a shiny look and can make colors look very bold and vibrant. A matte finish creates a duller, more neutral finish, without a shiny reflective surface. When you choose a varnish, it's important to know its finish.

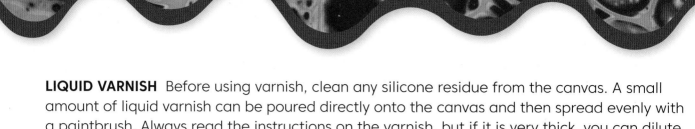

LIQUID VARNISH Before using varnish, clean any silicone residue from the canvas. A small amount of liquid varnish can be poured directly onto the canvas and then spread evenly with a paintbrush. Always read the instructions on the varnish, but if it is very thick, you can dilute it with a small amount of water and then brush it onto the canvas. Let the varnish dry before hanging your painting.

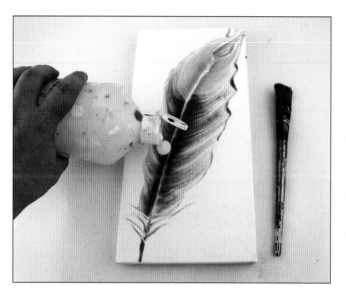
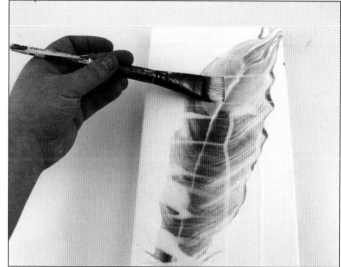

SPRAY VARNISH You may apply spray varnish much like spray paint. Read the safety instructions on the can before use. I like to use spray varnish outside since there are a lot of fumes, but make sure you follow all safety instructions for the spray varnish, work in a well-ventilated area, and always wear respiratory protection. Spray varnish is flammable, so have a fire extinguisher on hand.

Rest your canvas on a flat surface, shake the can as necessary, and apply a thin, even spray of varnish over the piece. For even coverage, use multiple light coats rather than one very heavy coat.

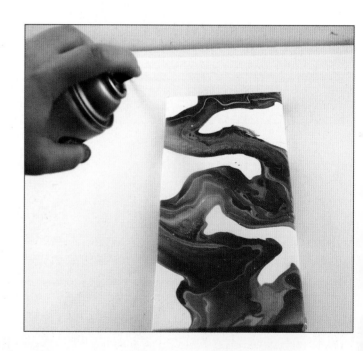

Resin

My favorite finishing product is epoxy resin. Dried resin will give your painting a glasslike finish and can make the colors and details really "pop." To give you some perspective, one coat of resin is equal to about 40 to 50 coats of varnish.

There are many types and brands of resin. I specifically use epoxy resin meant for tabletops, as it is extremely durable once cured (see below) and creates a protective surface over my artwork. This resin is waterproof and scratch-resistant, so I also use it on coasters (see pages 121-125).

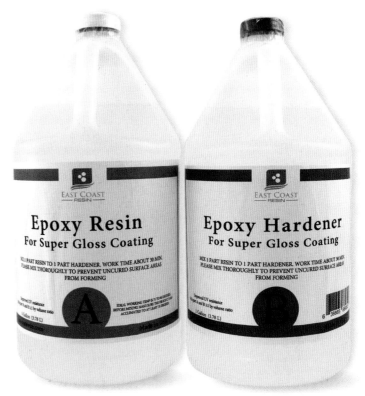

Curing refers to the chemical reaction that causes materials to harden.

RESIN IS NOT MICROWAVABLE OR DISHWASHER SAFE. I CLEAN MY COASTERS USING A DAMP WASHCLOTH.

Resin can be purchased online and in stores, including craft and home-improvement stores. Resin fumes can be toxic and harmful, so always wear gloves and a mask. If you get resin on your skin, you can remove it using rubbing alcohol. When working with resin, I always use my kitchen torch to remove any air bubbles. For safety, keep a fire extinguisher in your work area when working with flammable material and a torch.

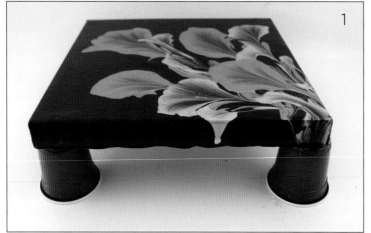

To use resin, prepare your work surface by placing freezer paper on a flat surface and taping the back of the canvas so that you can remove the hardened resin when you are finished. Rest the canvas levelly on cups so that the resin can drip off. Put on gloves and a respirator, and consider wearing goggles as well for extra protection.

Read the instructions on the resin before preparing it. With the resin that I use, I mix equal parts resin to hardener; however, some resins require ½ part hardener to 1 part resin

Combine the hardener and resin and mix, again following the instructions on the resin so that you know how long to mix it. The resin and hardener may not cure correctly if not mixed long enough.

Once you've mixed your resin, you have only a limited amount of time to use it before it hardens. The resin I use gives me about 20 to 30 minutes of working time.

Pour the resin onto your painting, and use a stir stick to spread the resin evenly across the surface. Use a gloved hand to make sure the edges and corners are covered as well.

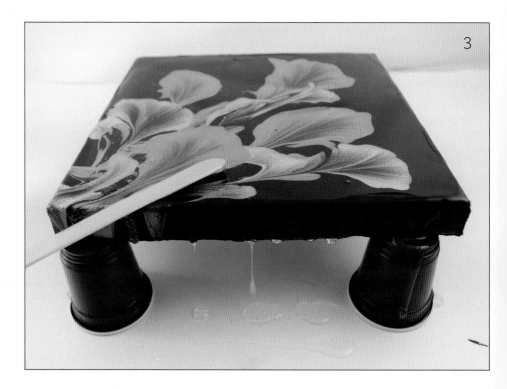

Apply a kitchen torch over the entire canvas to remove air bubbles. Do not keep the flame in one spot for too long to avoid burning the resin.

Keep your canvas on a flat surface while it cures. Resin takes about 24 hours to harden and 72 hours to cure. After 24 hours, you can add a second coat of resin if the coverage is uneven.

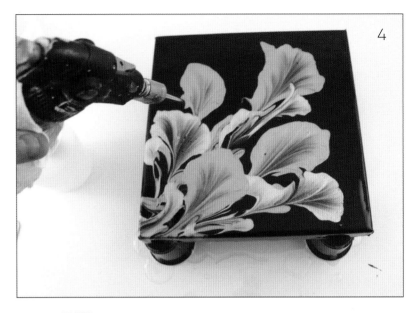

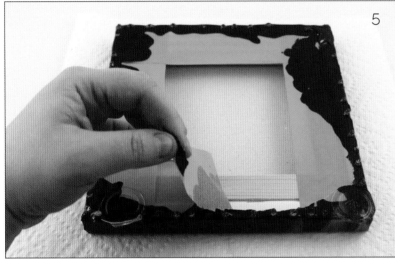

Wait a week or so before removing the tape from the back of the canvas. Before removing the tape, place the canvas facedown on a towel or paper towel to avoid scratching the front of the painting. Then peel off the tape and use scissors or a knife to peel the drops of resin from underneath the tape.

Here is the finished piece with resin.

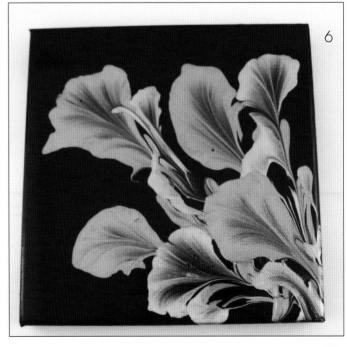

Saving Leftover Paint

When painting, try mixing up the leftover paint for other projects. You can store the paint in various containers, such as plastic food containers, mason jars, or even cups with plastic wrap and a rubber band around them. Some artists even reuse empty paint bottles to store their paints.

Mix your paint in any thickness you like and store it for later use. Pour directly from the condiment container, or pour the paint into a cup, check the consistency, and prepare your pour.

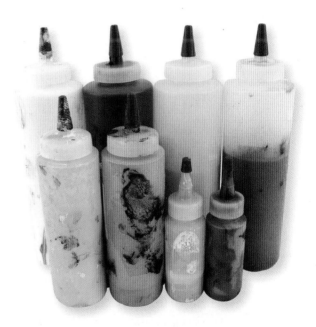

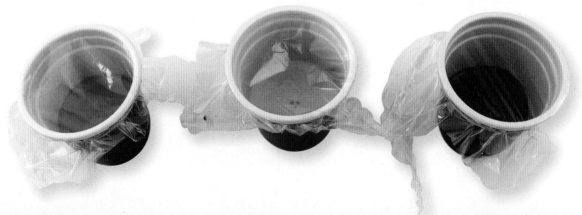

ONCE YOU'VE USED UP ALL OF THE PAINT IN YOUR CONTAINER, RINSE IT OUT AND REUSE IT THE NEXT TIME YOU POUR!

You can also save leftover paint by pouring it onto a surface and creating acrylic skins. Acrylic skins are pieces of dried acrylic paint that can be used in other projects. I love saving paint this way because I can make so many other items, from jewelry and hair clips to bookmarks.

Pour the leftover paint onto silicone baking mats, watercolor paper, or freezer paper, and let the paint dry. Once dry, you have a perfect skin to use for other projects!

Here I did a small dirty pour (pages 40-45) using leftover paint onto watercolor paper and a silicone baking mat.

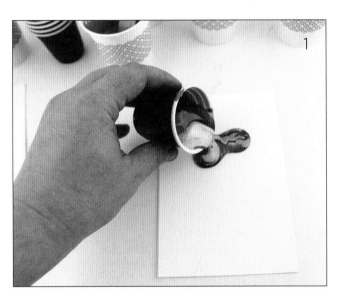

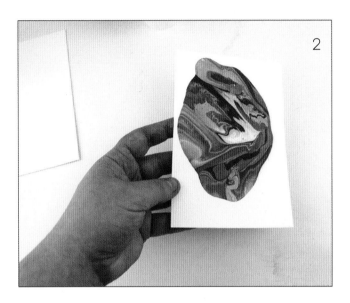

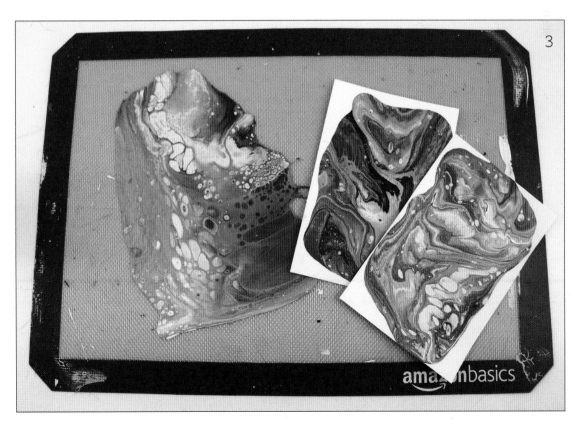

Step-by-Step Projects

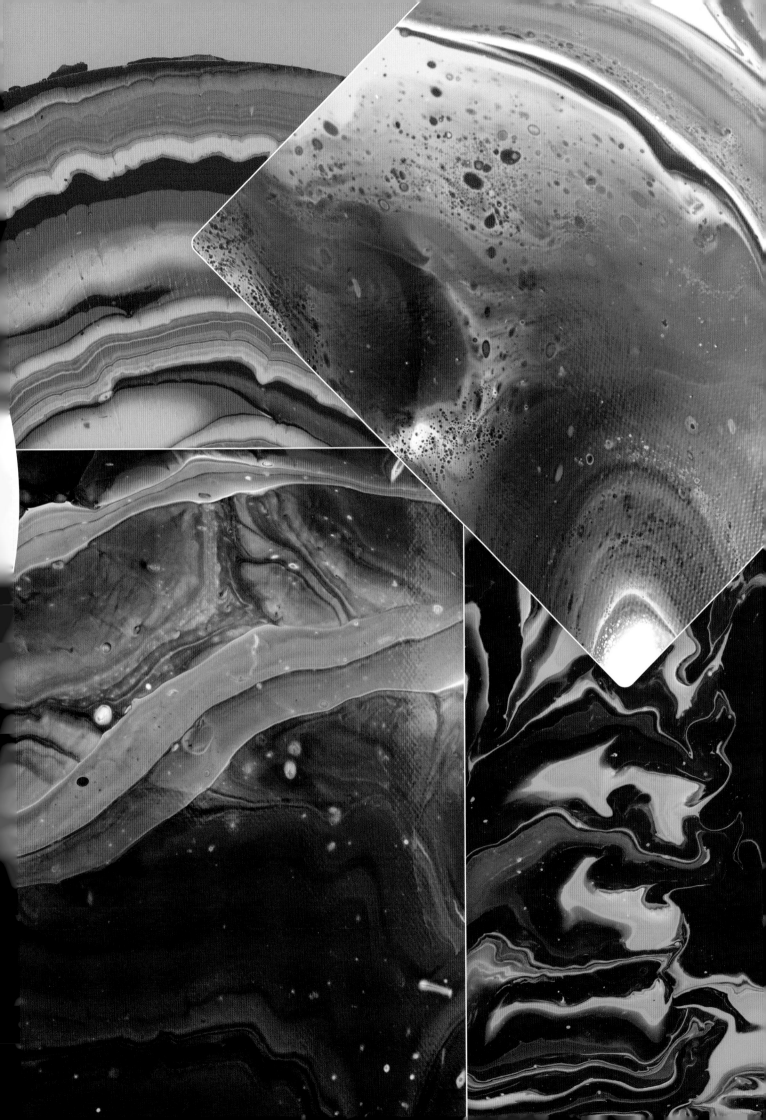

Dirty Pour

When I was learning to pour paint, the first technique I tried was the dirty pour. With the dirty pour, combine all your paints in one cup, and then pour that cup onto the canvas.

There are a few variations that will change the outcome of your final piece. If you want a more blended pour, use a stir stick to gently swirl through the paint in your cup. If you'd like less blending, pour the paints down the side of the cup to layer them before pouring.

TOOLS & MATERIALS:
- Freezer paper
- Canvas
- Cups
- Tape
- Paint (I used GOLDEN® Fluid Acrylics)
- Pouring medium (I used GOLDEN)
- Stir sticks
- Water

Optional tools for creating cells:
- Liquid silicone or dimethicone
- Torch

IF YOU PLAN TO LEAVE THE CANVAS ON THE CUPS WHILE DRYING, USE A LEVEL TO CHECK THAT THE CANVAS SITS EVENLY. IF IT SITS UNEVENLY, YOUR PAINT AND FINAL DESIGN MAY SHIFT AND CHANGE WHILE DRYING.

STEP 1

Cover your flat working surface with a sheet of freezer paper or another item, such as a plastic bag, newspaper, or a tablecloth.

Rest your canvas on top of the cups. I use four—one for each corner. Resting the canvas on cups allows excess paint to run off the sides.

Optional: If you'd like to prep your canvas beforehand, you can tape the bottom of the canvas to keep it free from paint. See page 19 for instructions.

STEP 2

Add each paint color to a separate cup. I used white, teal, Prussian blue, magenta, and gold.

Each pouring medium comes with its own mixing instructions. In this project, I used a pouring medium by GOLDEN, which suggests mixing 1 part paint with 9 parts medium. This medium is white but dries clear.

Thoroughly mix the paint and pouring medium, and add water if desired to thin your mixture.

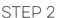

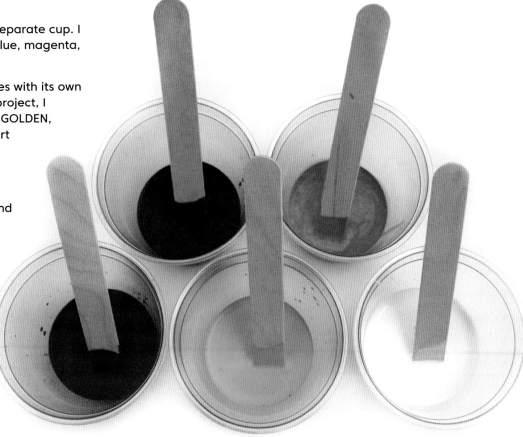

Optional: If you choose to use an additive to help create cells, add it after mixing the medium and paint. Use only one or two drops, gently stirring it into your paint/medium mixture.

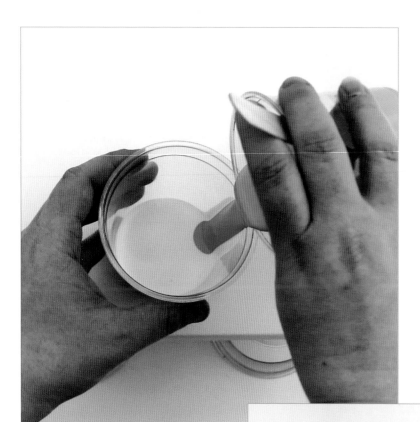

STEP 3
Now you are ready to begin pouring! Pour your paint mixtures into a clean cup. You may pour the paint in any order and volume.

The method you use to pour the paint will affect how your design turns out. If you want your colors more blended, pour them in the middle of the cup. The weight of the paint will pull the color from the top to the bottom of the paint mixtures in the cup. If you want less blending, pour your paint down the side of the cup. This will layer the colors, rather than pulling them through.

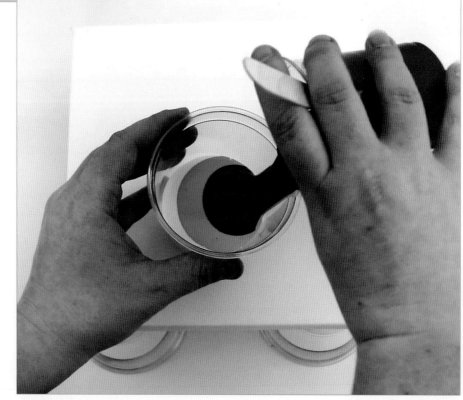

AFTER ADDING ALL YOUR PAINT COLORS TO THE CUP, YOU CAN USE A STIR STICK TO GENTLY STIR THROUGH THE CUP ONCE OR TWICE. DO NOT OVERMIX OR THE PAINT WILL LOOK MUDDY. GENTLY MIXING THE PAINT CREATES A MORE BLENDED COLOR PALETTE ON THE CANVAS.

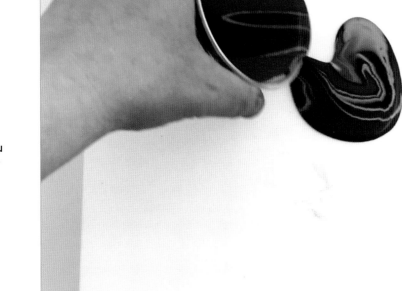

STEP 4
Pour the paint onto the canvas using any design you like: diagonally, in a circular motion, or in one large puddle in the middle.

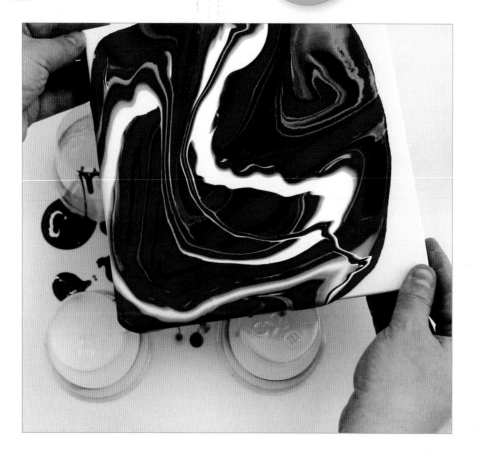

STEP 5

Once you've poured the paint onto the canvas, pick up and tilt the canvas in any direction. Keep areas of paint that you like, and tilt off the areas you don't like.

If you don't like what you've poured and tilted, don't worry! Add more paint to your cup and pour it onto the canvas. The paint stays wet for a couple of days, so you can take your time and manipulate the paint any way you like. There is no need to rush the process.

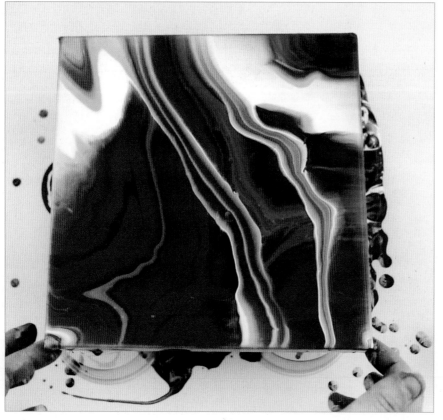

STEP 6

When you're happy with your design, rest the canvas on a flat surface or on top of the cups to let the paint dry. Check the sides and edges of the canvas to make sure they're completely covered with paint. If you see blank spots of canvas, use leftover paint to touch up those areas by hand.

YOUR PAINT WILL TAKE ONE TO THREE DAYS TO DRY. KEEP IN MIND THAT TEMPERATURE AND HUMIDITY LEVELS WILL AFFECT DRYING TIME.

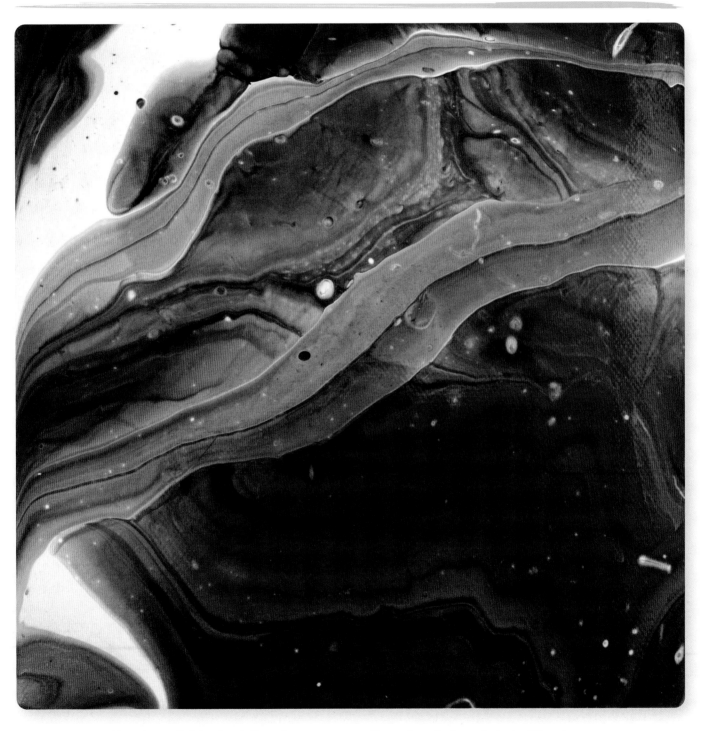

Here is my finished painting. As you can see, the colors darkened nicely. When I was pouring the colors, I thought the gold might get lost next to the other paint colors. But once it dried, the shine of the metallic gold paint showed through.

Flip Cup

With flip cup, another popular basic technique for paint pouring, you mix all your colors individually, add them to a single cup, flip the cup onto the canvas, and then pull away the cup to reveal the paint.

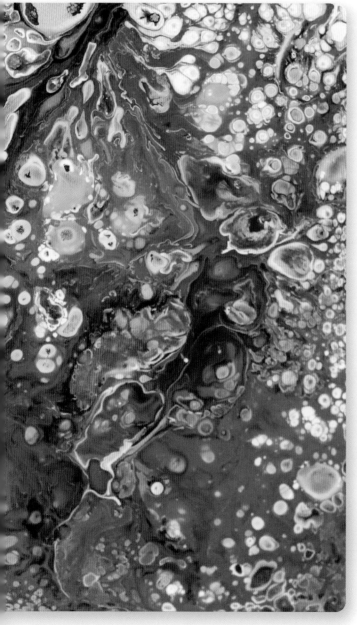

TOOLS & MATERIALS:
- Freezer paper
- Canvas
- Cups
- Tape
- Paint
- Pouring medium (I used Liquitex®)
- Stir sticks
- Water

Optional tools for creating cells:
- Liquid silicone or dimethicone
 (I used 100-percent liquid silicone)
- Torch

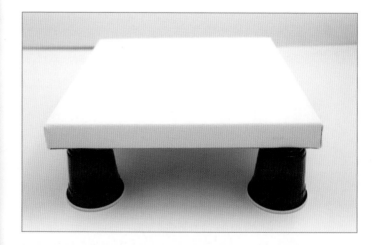

STEP 1
Lay a sheet of freezer paper over your flat surface, and prop up your canvas on four cups so the excess paint will run off the sides of the canvas while it dries. You can also tape the back of the canvas to keep it clean from paint (see page 19).

IF YOU'RE WORKING ON A LARGE CANVAS, YOU MAY WANT TO USE MORE THAN FOUR CUPS TO SUPPORT THE CANVAS AND ENSURE THAT IT STAYS LEVEL. REST THE CUPS ON THE WOOD FRAME OF THE CANVAS, NOT THE ACTUAL CANVAS. IF THE CANVAS MATERIAL RESTS ON THE CUPS, THE CUPS' INDENTATIONS MAY BE VISIBLE ONCE YOUR ARTWORK DRIES.

STEP 2

Select your paint colors and pour each one into an individual cup. I used turquoise, magenta, and white. Add your pouring medium following a ratio of about 2 parts medium to 1 part paint, and mix thoroughly.

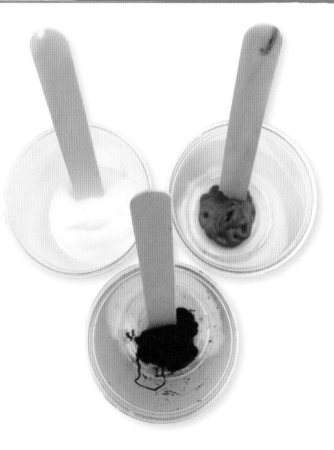

STEP 3

Slowly add water until the mixture reaches the consistency that you prefer for pouring. I added about 1 tablespoon at a time and mixed it in; then I checked if I need more water.

IF YOU ADD TOO MUCH WATER AND THE PAINT MIXTURE BECOMES TOO THIN, ADD A SMALL AMOUNT OF PAINT TO THICKEN IT BACK UP. PRACTICING WITH DIFFERENT CONSISTENCIES CAN HELP YOU DETERMINE HOW THICK OR THIN YOU LIKE YOUR PAINT.

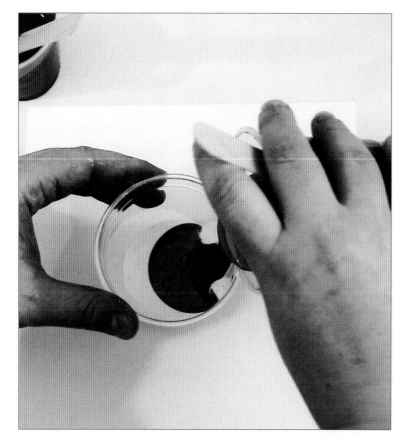

STEP 4
Add one or two drops of silicone or dimethicone to your paint mixtures; then gently mix. Grab a clean cup and add your paint mixtures in any order and amount.

Optional: With a stir stick, swirl through the paint once or twice to blend the colors slightly.

STEP 5
Now for the fun part! Hold the cup of paint in one hand and the canvas in the other. Place the canvas on top of the paint cup, and flip both over.

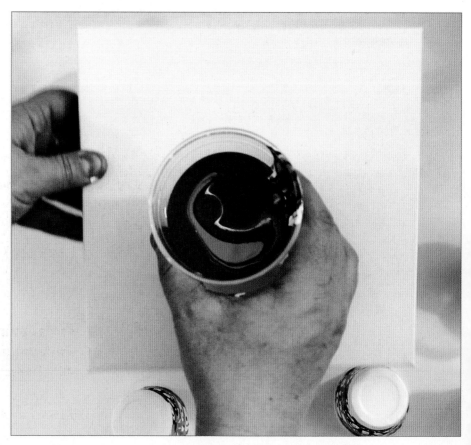

IF YOU NOTICE CRATERS OR AREAS OF PAINT PULLING AWAY FROM THE CANVAS, YOU MAY HAVE ADDED TOO MUCH SILICONE, OR YOUR PAINT MIXTURE COULD BE TOO THIN. REMIX AND TRY AGAIN!

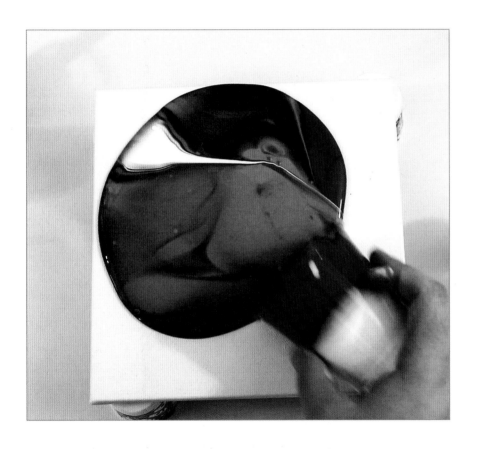

STEP 6
Place the canvas back on the resting cups. You can let the cup of paint sit on the canvas for a minute or immediately remove it. Make sure to pull the cup away from the paint at an angle; do not lift it.

IF YOU LIFT THE CUP FROM THE CANVAS, PAINT MAY DRIP AND RUIN YOUR DESIGN. PULLING AWAY THE CUP WILL AVOID THIS MISTAKE.

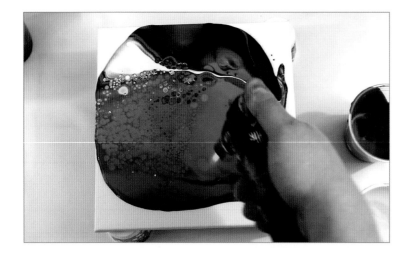

STEP 8

Before tilting your canvas, you may use a kitchen torch to create cells in the artwork. By torching first and tilting second, you can create cells and then tilt them to form larger cells across the canvas. If you prefer smaller cells, tilt first and then torch.

I chose to torch both before and after tilting to create cells in areas where none appeared.

REMEMBER NOT TO HOLD THE TORCH TOO CLOSE TO THE CANVAS OR IN ONE PLACE FOR TOO LONG TO AVOID BURNING YOUR ARTWORK.

TORCHING TO CREATE CELLS

Tilted then torched

Torched then tilted

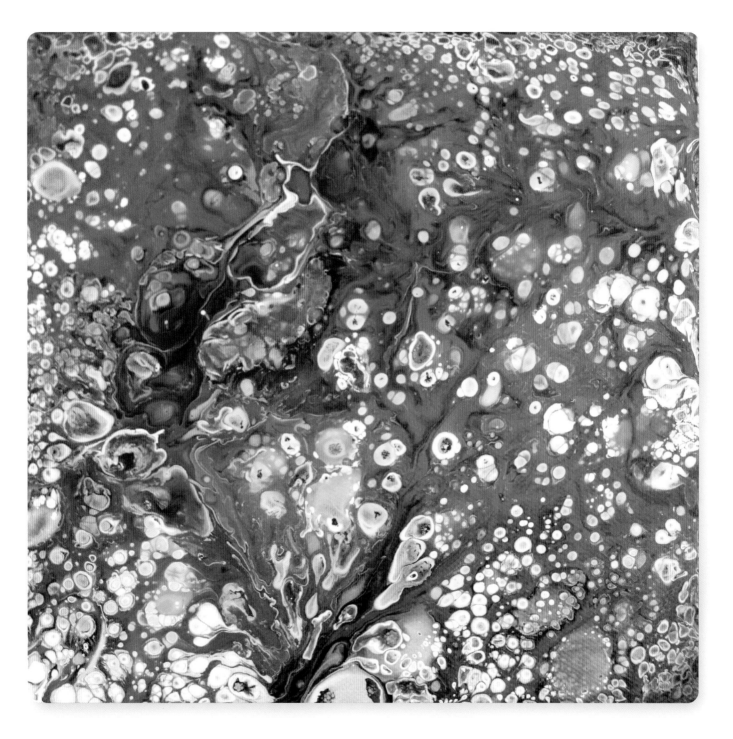

STEP 9

Once you've tilted your canvas into a design that you like, touch up the sides and edges of the canvas, and then rest the canvas on the cups or another flat surface to dry.

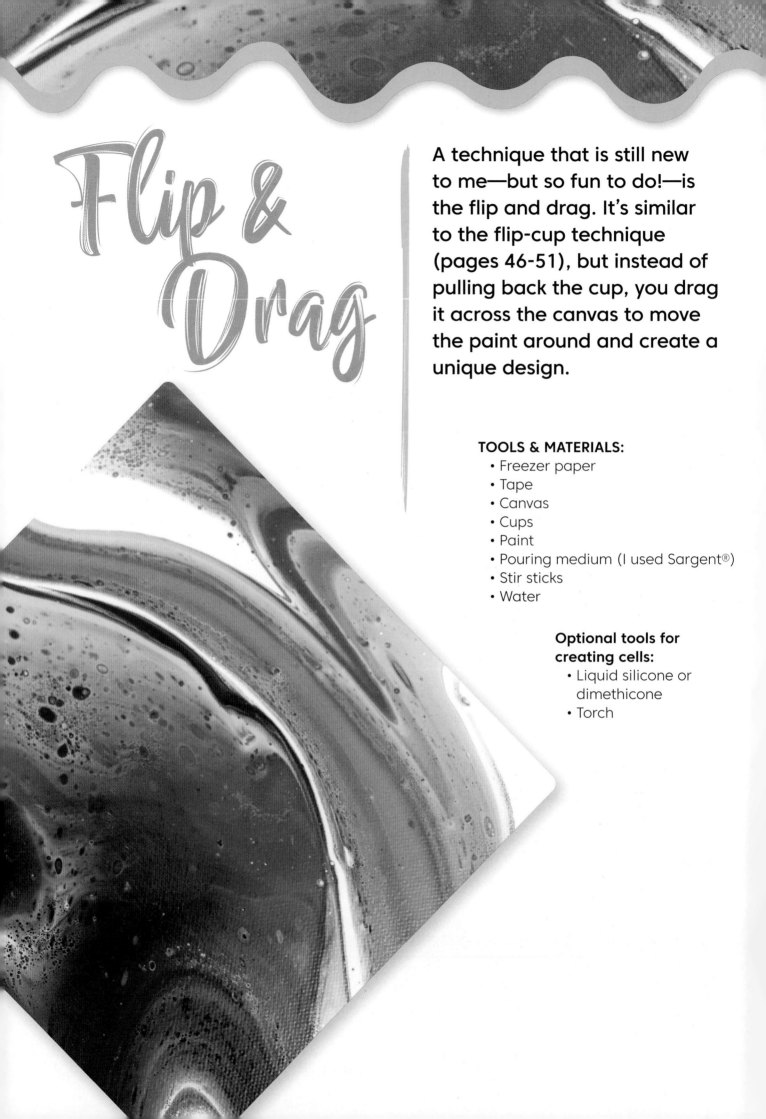

Flip & Drag

A technique that is still new to me—but so fun to do!—is the flip and drag. It's similar to the flip-cup technique (pages 46-51), but instead of pulling back the cup, you drag it across the canvas to move the paint around and create a unique design.

TOOLS & MATERIALS:
- Freezer paper
- Tape
- Canvas
- Cups
- Paint
- Pouring medium (I used Sargent®)
- Stir sticks
- Water

Optional tools for creating cells:
- Liquid silicone or dimethicone
- Torch

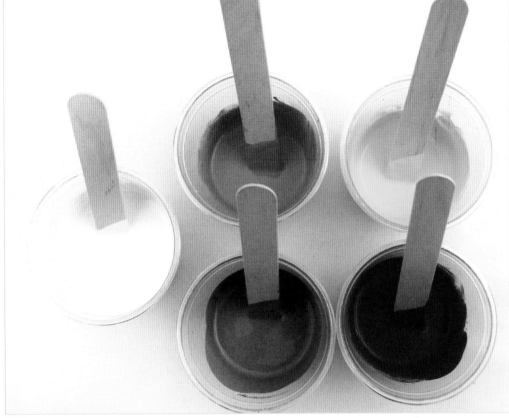

STEP 1

Cover your flat working surface with freezer paper, and tape the back of the canvas to keep it clean from paint. Then rest the canvas on cups to allow excess paint to drip off.

Pour the paint into cups. I used one of my favorite color palettes: white, yellow, orange, magenta, and turquoise. Then add pouring medium to each cup following a ratio of about 2 parts medium to 1 part paint. Mix, and then slowly add water until the paint mixtures reach the consistency that you like for pouring.

STEP 2

Add all of the paint mixtures to a single cup, except for the white. I added yellow, orange, turquoise, and magenta to my cup and kept the white separate.

Hold the cup in one hand and the canvas in the other. Place the canvas on top of the cup, flip both over, and rest the canvas on your prepared cups. I placed my cup in a corner of the canvas.

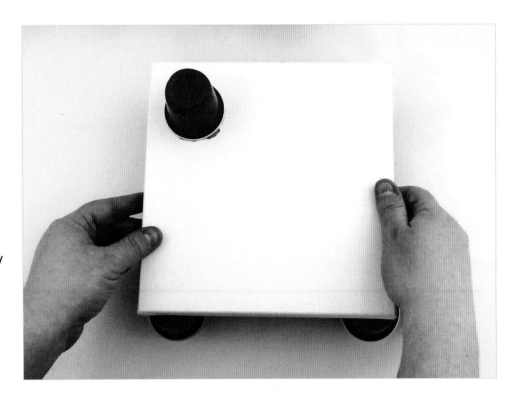

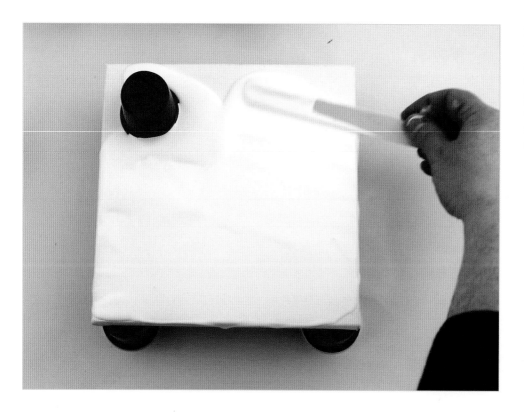

STEP 3

Pour white paint on the canvas surrounding the upside-down cup. The white paint will help you move your other colors across the canvas while also creating a unique design.

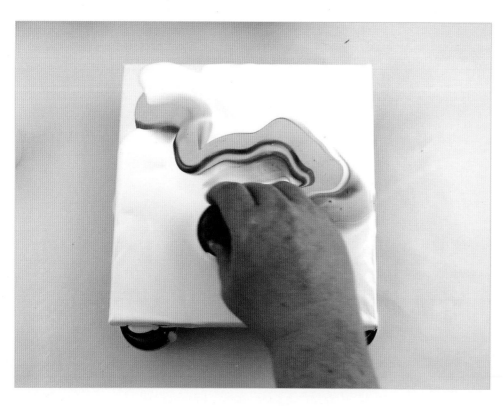

STEP 4

Begin sliding your first cup across the surface. Move it in any direction you like. If necessary, gently squeeze the cup to help release the paint as you drag the cup around the canvas.

STEP 5
With all the paint on the canvas, begin tilting!

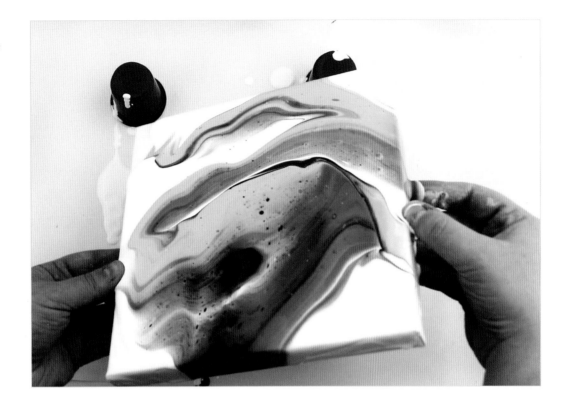

Optional: Even without silicone in the paint mixture, you can still use a torch to create small cells in your piece. I chose to torch mine to help bring out some of the colors that got lost in my artwork.

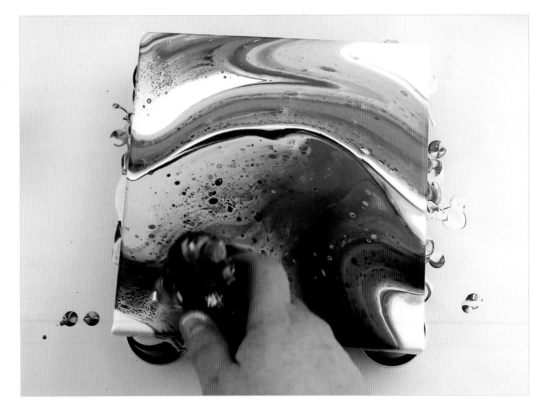

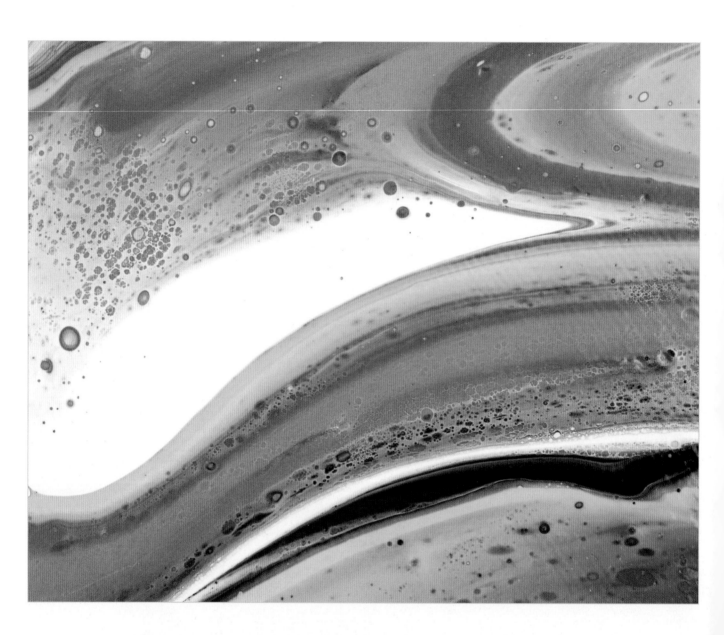

STEP 6

Once you've tilted the canvas and like your design, rest the artwork on a flat surface to dry.

Optional: Use a level to ensure that your drying surface is even. If it's uneven, your paint may move while drying.

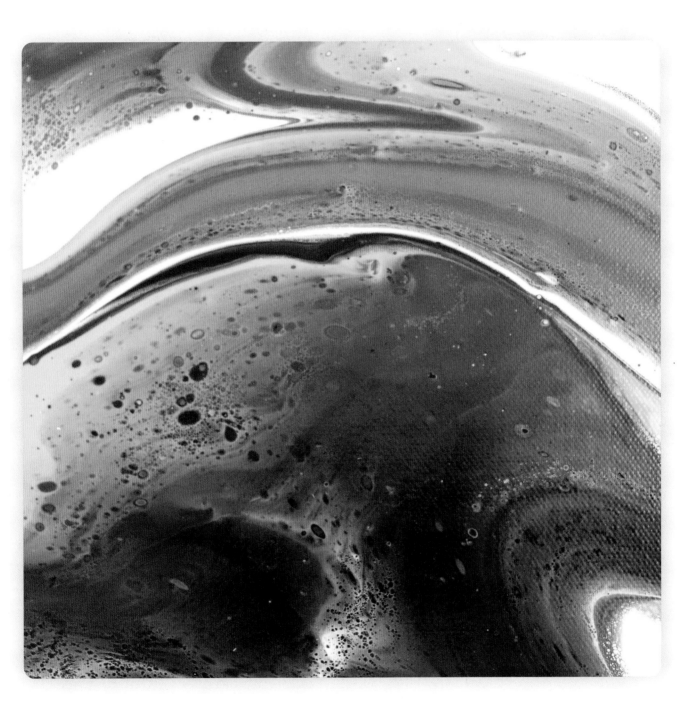

This is what the painting looks like after drying.

Straw-Blown Paint

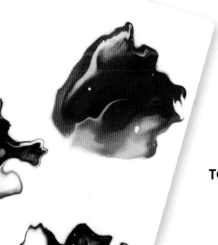

Using a straw to blow paint around on the canvas is a fun and super-easy way to create beautiful abstract flowers. I enjoy this technique not only for the awesome shapes I can create, but also for the great definition between colors that appears on the canvas.

TOOLS & MATERIALS:

- Freezer paper
- Cups
- Paint
- Pouring medium (I used Atelier®)
- Stir sticks
- Water
- Canvas
- Palette knife
- Straws

Optional tools for creating cells:

- Liquid silicone or dimethicone
- Torch

STEP 1

Cover your work surface with freezer paper and prepare your paint mixtures. To make small flowers, you need only about 1 tablespoon of each color. I used red, magenta, orange, and yellow, as well as a larger amount of white to cover the canvas.

Add about 2 tablespoons of pouring medium to each cup and incorporate. Slowly add water until your paint reaches the consistency that you like for pouring.

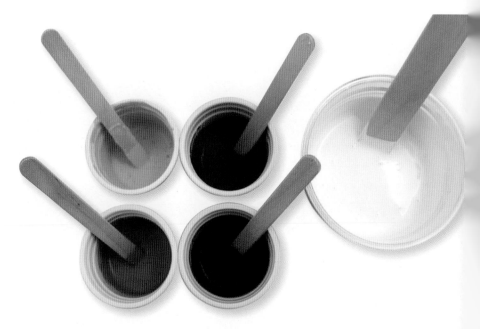

STEP 2

Rest the canvas on top of cups. Then prepare your canvas, using white as the base coat. Use a palette knife to spread the white paint, or pour the paint onto the canvas and tilt it to form an even coat of white over the entire canvas.

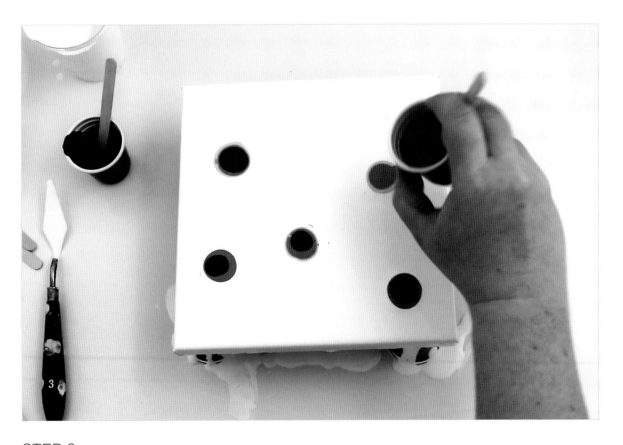

STEP 3

Pour puddles of paint on the canvas in any order you like. To make small flowers, I pour a puddle about the size of a quarter for each flower. For larger flowers, pour larger puddles. Depending on the size of the canvas, you can create a variety of sizes across the canvas.

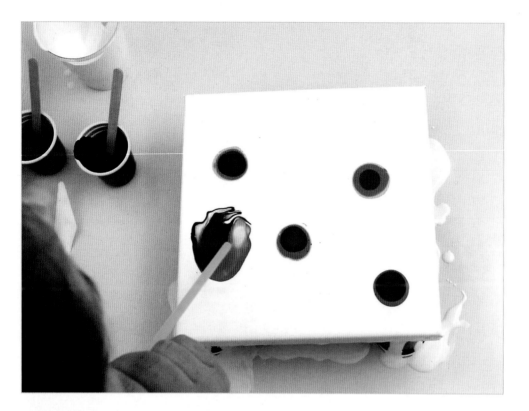

STEP 4
Use a straw to blow the paint puddles in any direction. I blew upward and the result reminds me of tulips!

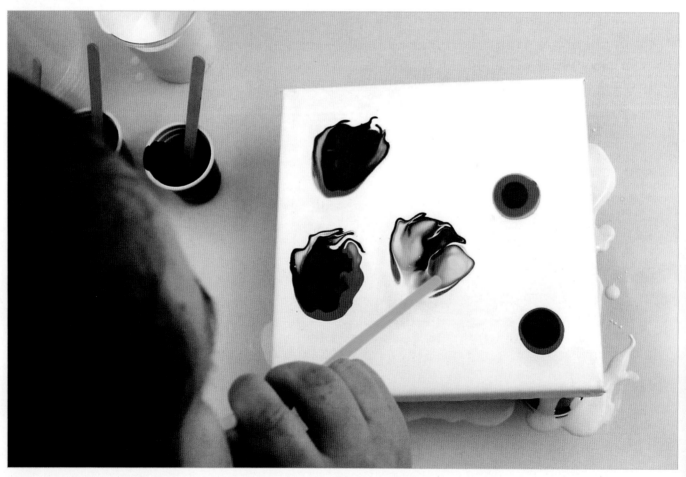

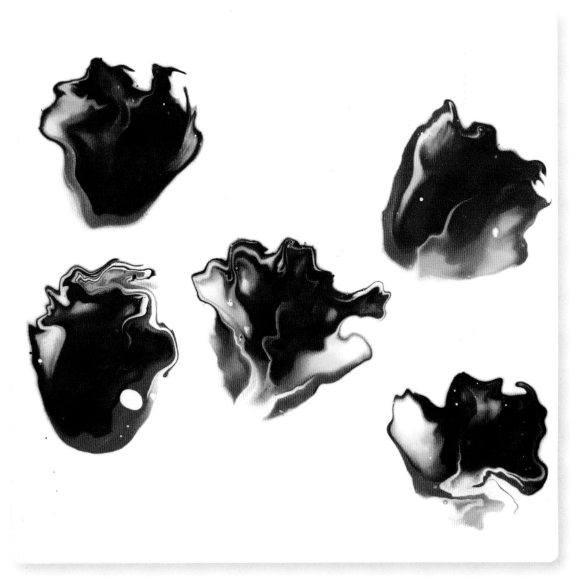

Here is my final piece. To see how I embellished the same piece with stems, turn to page 115.

VARIATION: HAIR DRYER-BLOWN PAINT

Another way to blow paint around the canvas is with a hair dryer. This is quickly becoming one of my favorite techniques. I love how the colors blend, and it's a great way to create cells without adding silicone or dimethicone to the paint.

For this piece, I used a wood circle instead of canvas, and I added more water than usual to my paint mixtures to thin them slightly more. Thinner paint blends well when you use a hair dryer.

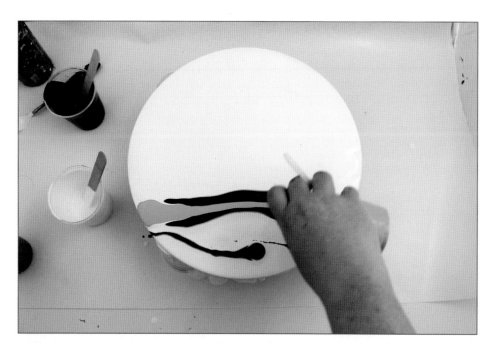

STEP 1
Follow steps 1 and 2 on pages 58-59 to prepare your paint mixtures and surface. Then pour the paint mixtures onto the surface in any pattern you like. I wanted to keep some negative space at the top of the painting, so I applied my paint at the bottom.

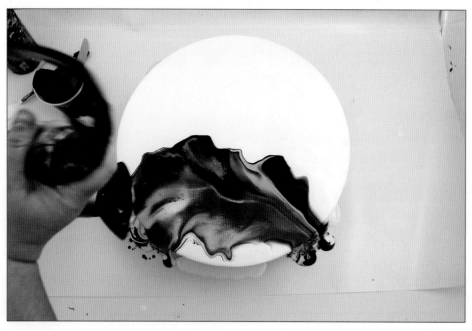

STEP 2
Now grab a hair dryer and blow it over the paint any way you like!

USING A HAIR DRYER TO MOVE THE PAINT IS A GREAT WAY
TO MAKE CELLS IN YOUR POURED ARTWORK.

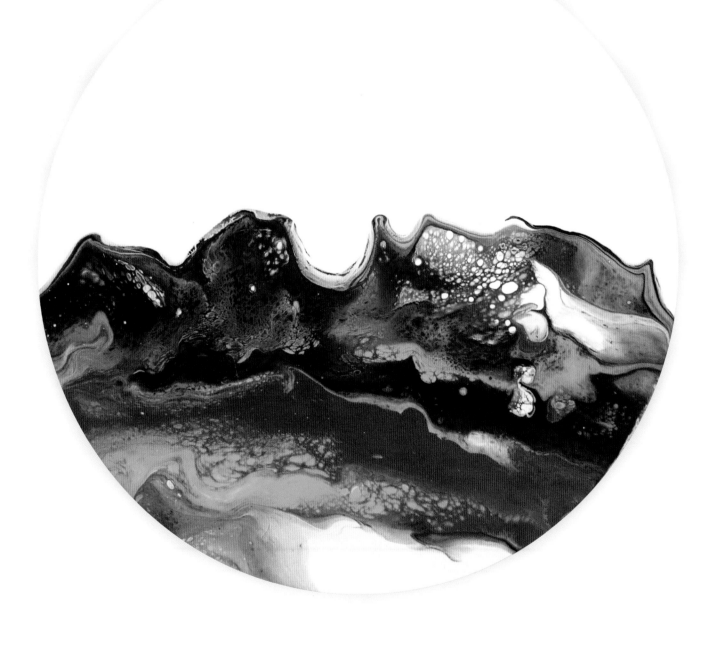

Dip

The dip technique is one of my favorites because of the way the paint blends, creating a very different outcome than what you usually see with poured paint. Here, I poured the paint onto a flat surface and then dipped the canvas in the paint. You can also pour the paint onto a canvas and then dip another canvas in the paint.

TOOLS & MATERIALS:
- Freezer paper
- Canvas
- Cups
- Tape
- Paint
- Pouring medium
 (I used PVA glue)
- Stir sticks
- Water

Optional tools for creating cells:
- Liquid silicone
- Torch

STEP 1

I used a rainbow-inspired color palette: red, orange, yellow, green, turquoise, blue, and purple, as well as some white.

Place freezer paper over a flat surface. For this technique, you do not need to rest your canvas on cups. Place tape on the back of the canvas.

Mix your paint and pouring medium, such as glue, following a ratio of about 2 parts glue to 1 part paint. Slowly add water and mix until you have the consistency that you like for pouring. Glue creates a thicker mixture than pouring medium, so it requires a little more water to form the right consistency.

Optional: If you would like to use silicone, add one or two drops now and gently mix.

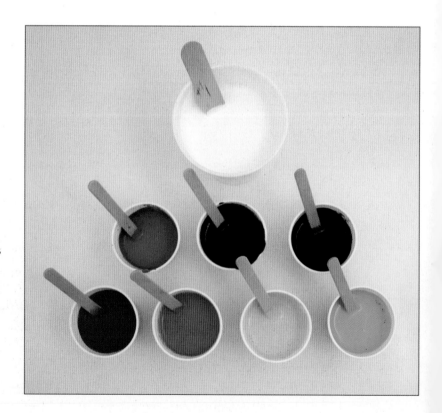

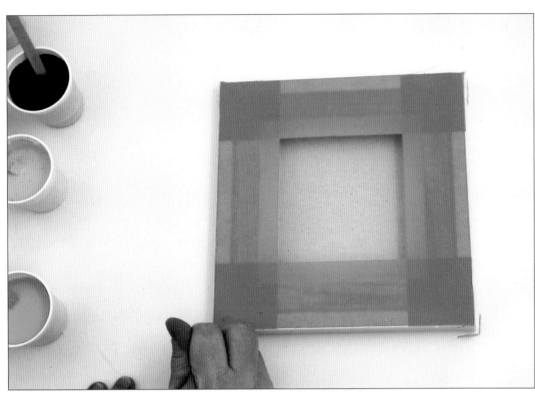

STEP 2

Mark the size of your canvas on the freezer paper; then pour the paint onto the freezer paper and dip the canvas in the paint. Marking the canvas on the freezer paper gives you a general outline so that you know when you've poured enough paint.

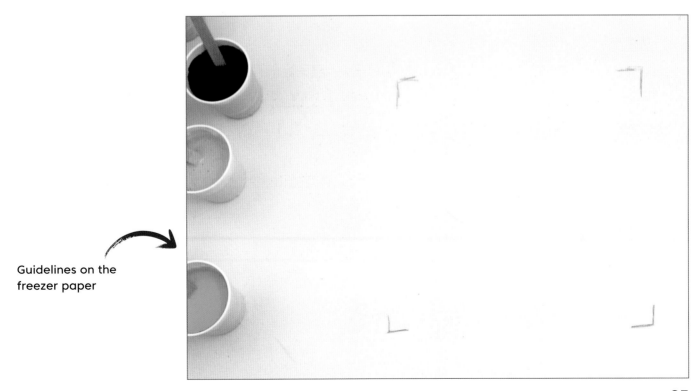

Guidelines on the freezer paper

STEP 3

Add your paint to a single cup and pour the mixture onto the freezer paper as a dirty pour (pages 40-45), or pour the colors separately in any pattern you like. I poured my colors individually into marked-off areas on the freezer paper so that I knew I had a spot for each color. Using white in the corners of the canvas creates negative space (pages 102-107).

STEP 4

Dip the canvas into the poured paint. There may be air trapped under the canvas; gently press on the center of the canvas to ensure that the entire canvas touches the paint. You can use a small stir stick to press the canvas evenly.

Then grab a canvas edge or corner, and gently pull the canvas away from the freezer paper.

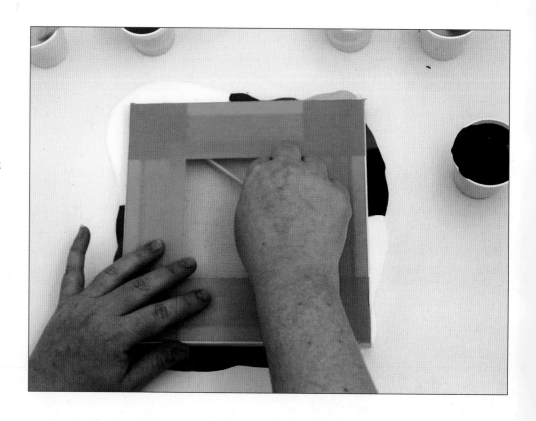

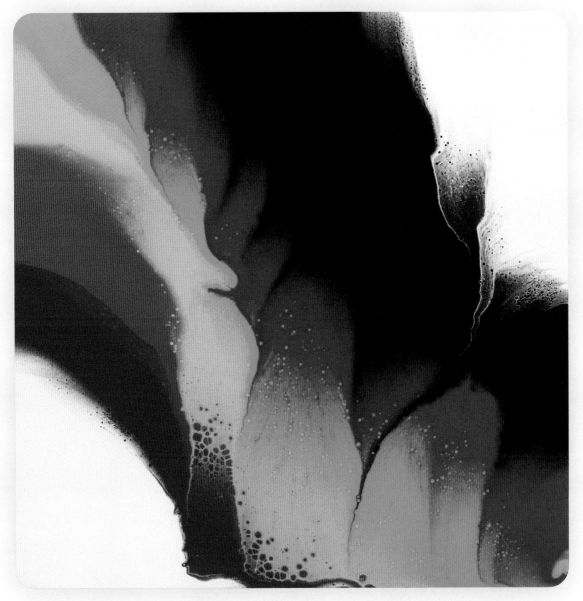

STEP 5

To cover the sides of the canvas, rotate it and dip each side in the paint. Set the canvas on a flat surface to dry, and make sure to touch up any areas where the canvas shows through.

IF YOU LIKE YOUR DESIGN BUT STILL HAVE BLANK AREAS ON THE CANVAS, DAB YOUR FINGER OR A PAINTBRUSH INTO THE PAINT AND COVER ANY BARE SPOTS. IF YOU DON'T LIKE YOUR DESIGN, YOU CAN RE-DIP THE CANVAS IN THE POURED PAINT.

OPTIONAL: EXTRA PAINT

I had a lot of paint left on my freezer paper, so I took some wood pieces and dipped them onto the canvas to make coasters later (pages 121-125). You can also dip additional canvases in the paint to create more paintings or dip pieces of paper in the paint to create skins for other projects, such as bookmarks, jewelry, and hair clips. Dried paint peels off freezer paper easily.

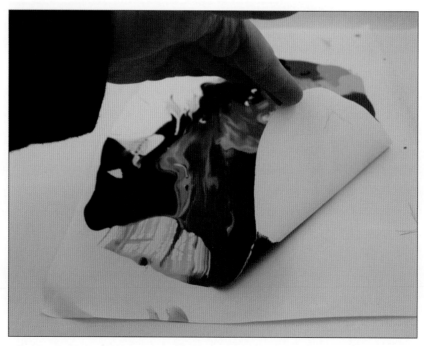

Dried paint on freezer paper

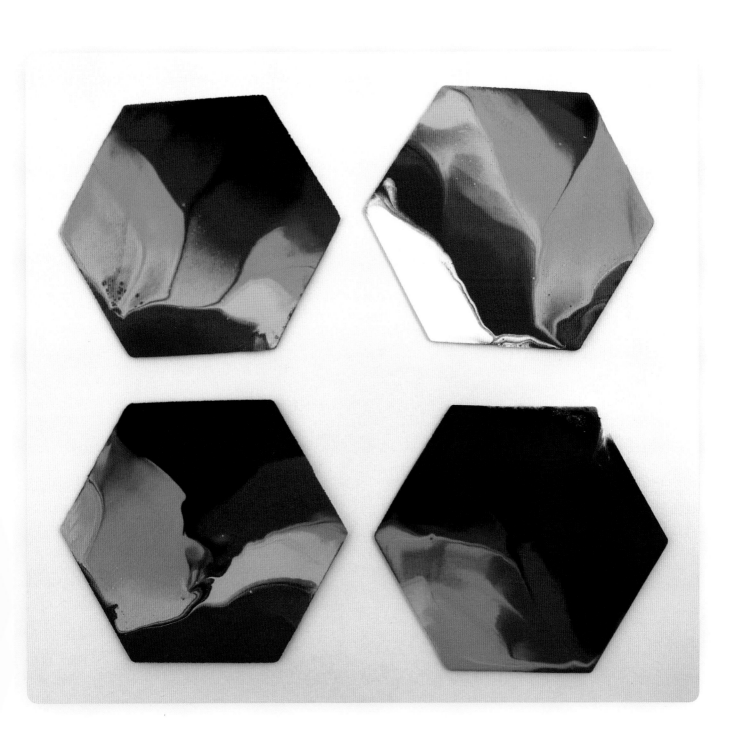

VARIATION: GLOVE DIP

A variation on the dip technique uses a glove or balloon to dip in the paint, producing a final result that looks like abstract flowers. You can customize the dips with different color palettes and create a canvas covered in dipped flowers or a negative-space piece with paint dipped only in some areas.

For this project, I will show you how to make coasters. You can use any shape you like as long as it's large enough to rest a cup on top (3-4 inches in diameter). I used leftover paint from my previous dip (pages 64-69) to demonstrate how a single palette can be used in a wide variety of projects!

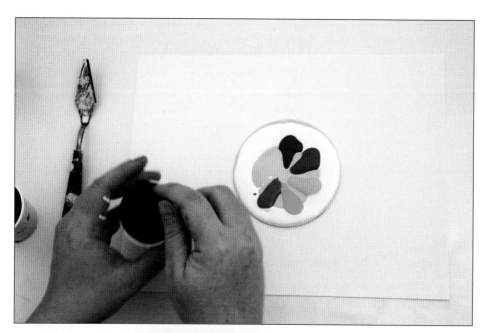

STEP 1

If you aren't using leftover paint, follow the mixing instructions for any of the techniques in this book. Add a drop of silicone if you want to produce cells in your artwork, and slowly incorporate water until the mixture has the consistency that you like for pouring.

Work on one coaster at a time, and pour your paint mixture any way you like onto each coaster. I poured white around the edge of each coaster to make the colors stand out.

STEP 2

Inflate the glove or balloon, and twist off the end to hold the air inside. Use both hands to press the glove into the poured paint. Apply even pressure on the glove so that you create a well-balanced design.

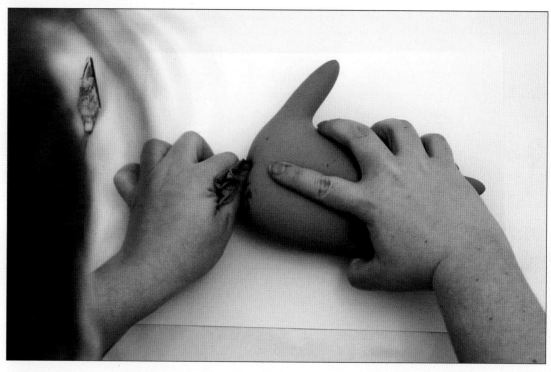

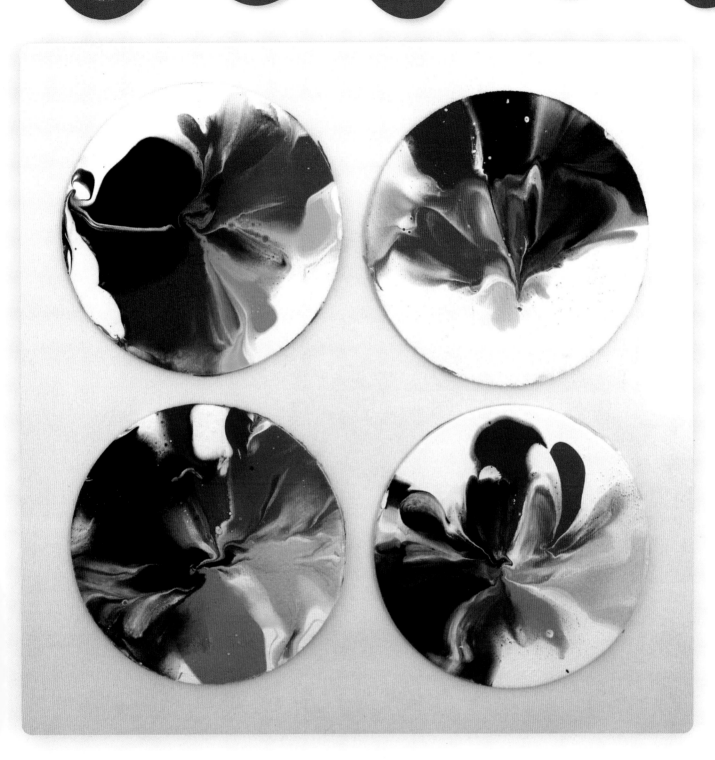

STEP 3
Repeat steps 1 and 2 until you've dipped as many coasters as you'd like.

YOU CAN WIPE THE PAINT FROM THE GLOVE TO REUSE IT, OR FLIP OVER THE GLOVE AND USE THE OTHER SIDE.

Tree Ring

This technique creates a beautiful ring pattern with acrylic paint. Simply move the cup in a circular pattern as you pour the paint. Mix it up by doing one pour or multiple on a single canvas.

TOOLS & MATERIALS:
- Freezer paper
- Cups
- Paint
- Pouring medium (I used Vallejo® pouring medium)
- Stir sticks
- Water
- Canvas

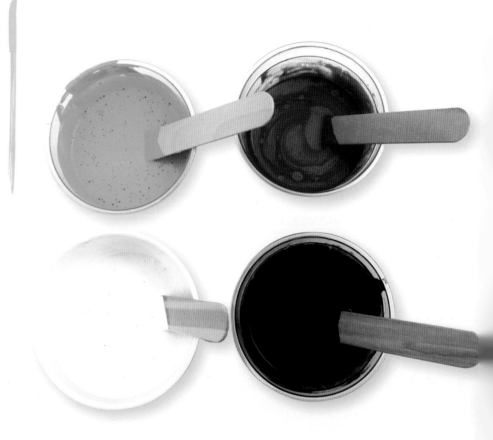

STEP 1
Cover a flat surface with freezer paper. Place four cups facedown on the freezer paper with the canvas on top of the cups. I used white, black, copper, and turquoise paint. Mix your paint and pouring medium following a ratio of about 2 parts medium to 1 part paint. Then slowly add water and incorporate until the mixture has the consistency that you prefer for pouring.

TO CREATE NICE, EVEN RINGS IN YOUR FINAL PIECE, DO NOT ADD SILICONE TO THE PAINT. SILICONE WILL CREATE CELLS AND BREAK UP THE RING PATTERN.

FOR THIS TECHNIQUE, I USUALLY KEEP MY PAINT A LITTLE THICKER TO CREATE DEFINED RINGS.

STEP 2

Spread white paint across the canvas to help the poured paint move around evenly.

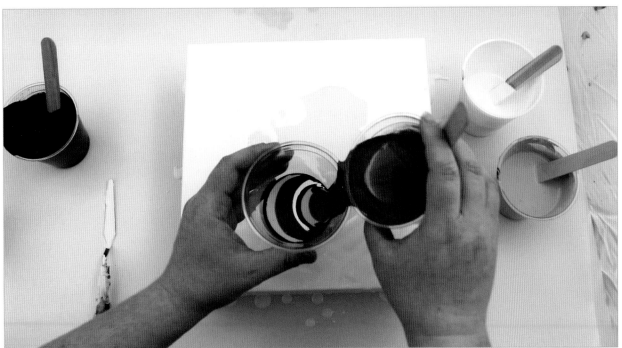

STEP 3

Gently add each paint mixture to your pouring cup. To layer the paint and create separation between the colors as you pour, pour the paint against the side of the cup.

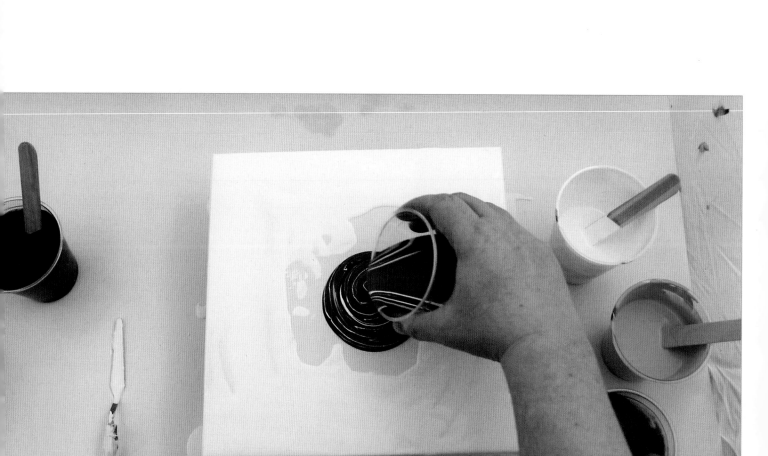

STEP 4

Pour the paint onto the canvas. To create the tree-ring effect, swirl the cup in a clockwise or counterclockwise circular pattern as you pour.

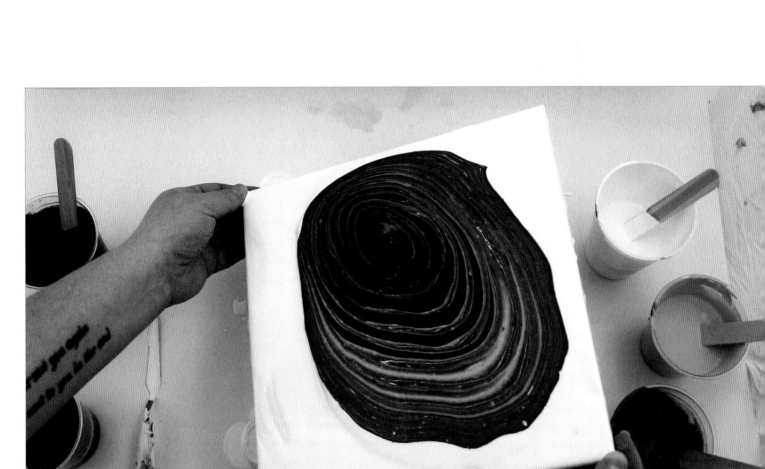

STEP 5
Gently tilt the canvas to spread the rings.

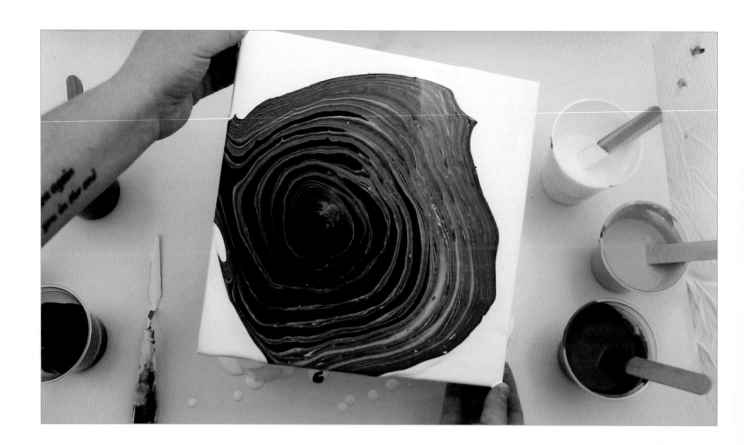

IF YOU LIKE YOUR PATTERN AND DON'T WANT TO KEEP TILTING, BUT THERE ARE STILL AREAS OF THE CANVAS SHOWING AT THE CORNERS OR EDGES, USE LEFTOVER PAINT AND A PAINTBRUSH, A PALETTE KNIFE, OR YOUR FINGERS TO TOUCH UP THE CANVAS.

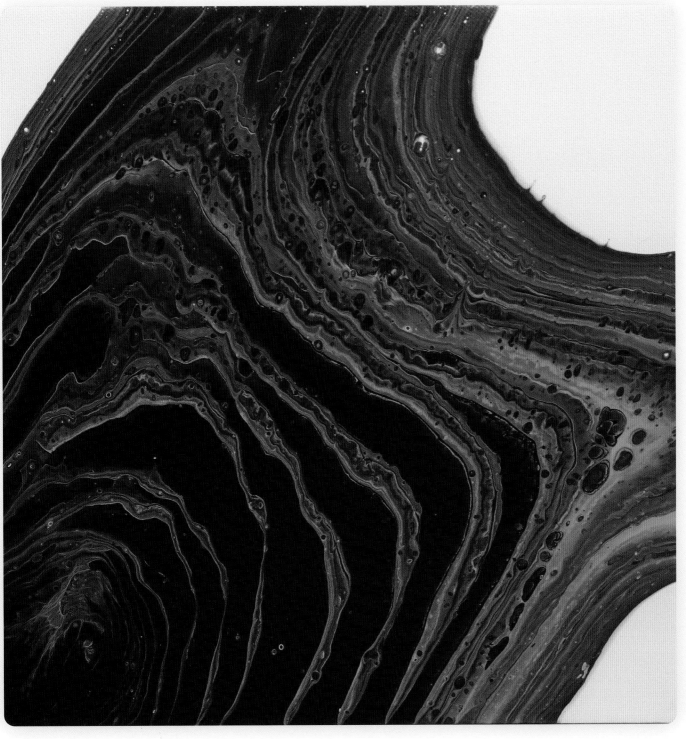

VARIATION: WANDERING TREE RING

A variation on the tree ring pour (pages 72-77), the wandering tree ring involves moving your cup in a circular motion over a large area of the canvas. I used a wood circle for this piece.

Because this technique involves pouring paint over the entire wood surface, not just in one spot like in the regular tree-ring pour, you don't need to put down a base coat of paint first.

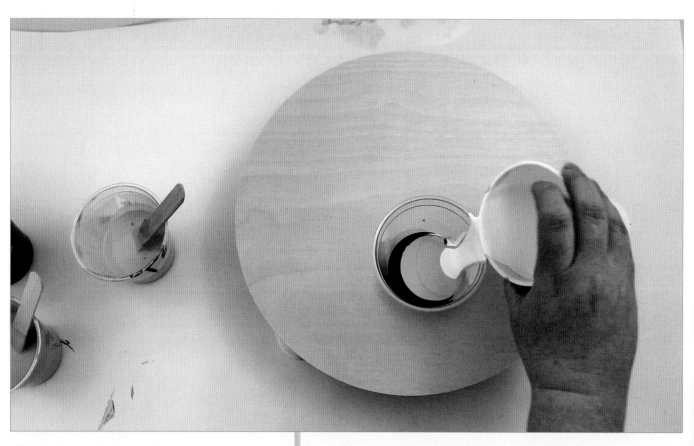

STEP 1
Follow steps 1-3 on pages 72-73.

PRIME YOUR WOOD SURFACE TO PREVENT WARPING FROM THE WATER ADDED TO THE PAINT.

AS WITH THE TREE-RING TECHNIQUE, I DID NOT ADD SILICONE TO MY PAINT MIXTURES BECAUSE I DIDN'T WANT TO CREATE CELLS THAT WOULD BREAK UP MY RINGS.

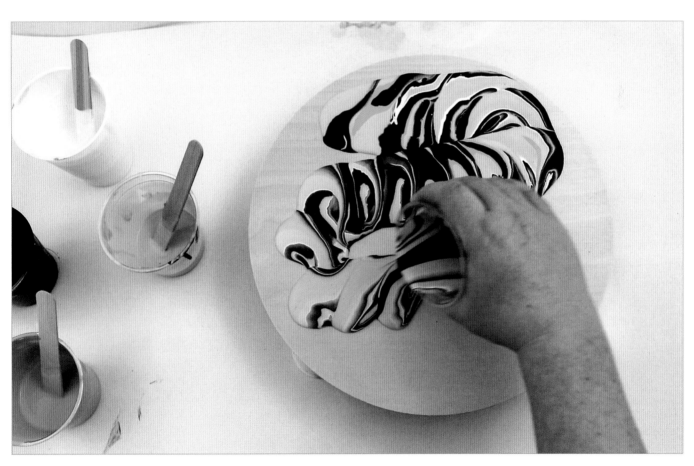

STEP 2

Begin pouring your paint, moving your cup in a clockwise or counterclockwise circular pattern. Let the cup wander across the surface!

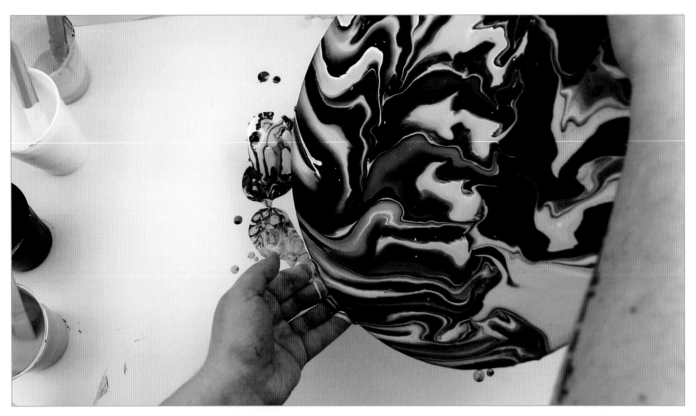

STEP 3
Now gently tilt the surface to spread the rings.

IF YOU LIKE THE PATTERN BUT HAVEN'T COVERED THE ENTIRE SURFACE, USE ONE OF YOUR PAINT MIXTURES TO FILL IN THE UNCOVERED AREAS.

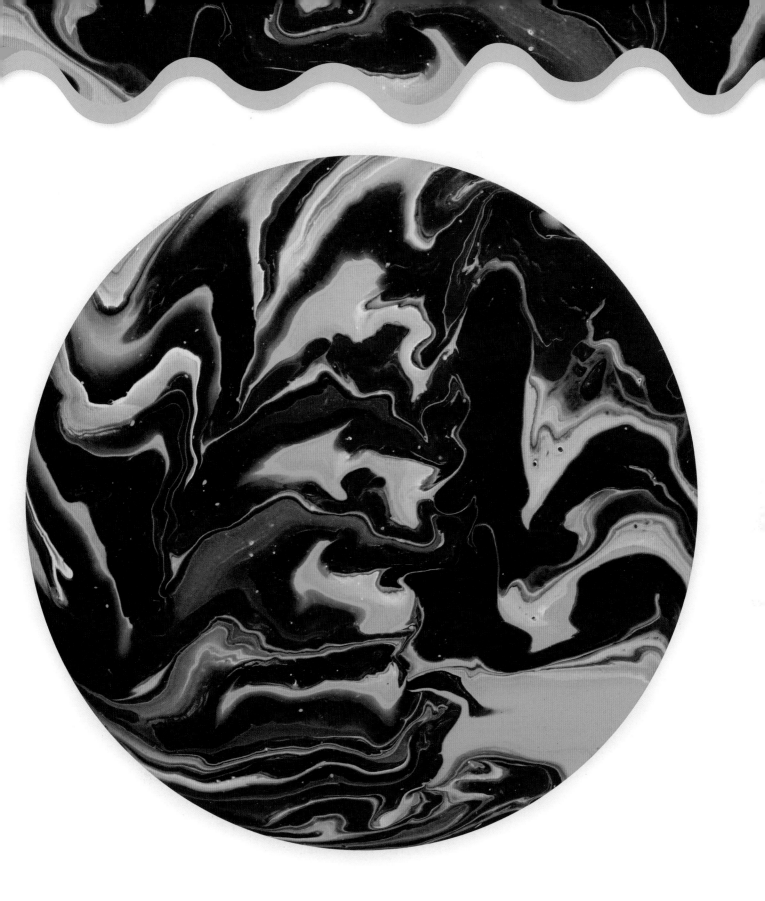

STEP 4
Rest the wood or canvas on a flat surface to dry.

Spinning Pour

For some really messy fun, spin your canvas while pouring! You'll need a banding wheel or lazy Susan for this project, which creates an awesome, abstract piece of art.

TOOLS & MATERIALS:
- Large box or plastic storage bin
- Lazy Susan, banding wheel, or anything else that you can get to spin!
- Freezer paper
- Old plastic or vinyl tablecloth
- Cups
- Paint
- Pouring medium (I used Testors® Craft Marbling Medium)
- Stir sticks
- Water
- Wood surface

Optional tools for creating cells:
- Liquid silicone
- Torch

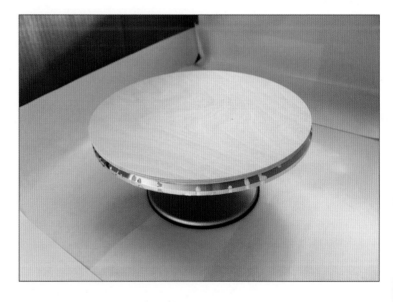

STEP 1
This technique can get really messy, so I used a different setup. Grab a box or storage bin with sides that are high enough to enclose the banding wheel or lazy Susan, as well as your wood surface.

PAINT AND MOISTURE CAN SOAK THROUGH CARDBOARD, SO I LINED THE BOX WITH FREEZER PAPER AND COVERED MY WORKING SURFACE WITH A TABLECLOTH.

STEP 2

Prepare your paint mixtures using a ratio of 2 parts pouring medium to 1 part paint. Then incorporate water until your mixtures form the right consistency.

I used a color palette of white, pink, peach, red, light rose gold, and metallic brown.

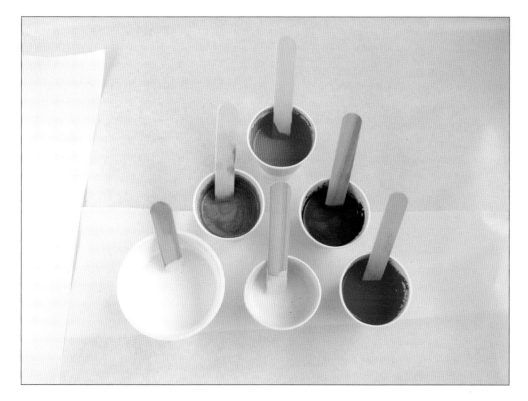

STEP 3

Tape the wood circle to the banding wheel to keep them together while spinning.

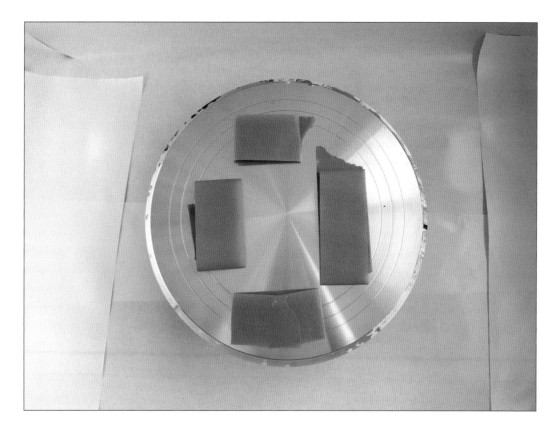

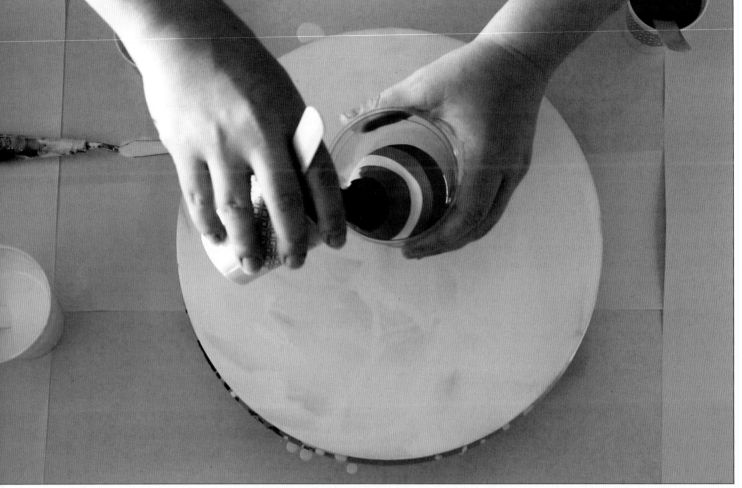

STEP 4
Apply a layer of white paint to the wood circle so the poured paint moves smoothly across the surface. Pour the paint mixtures into the cup any way you like. I layered my paint colors in the cup.

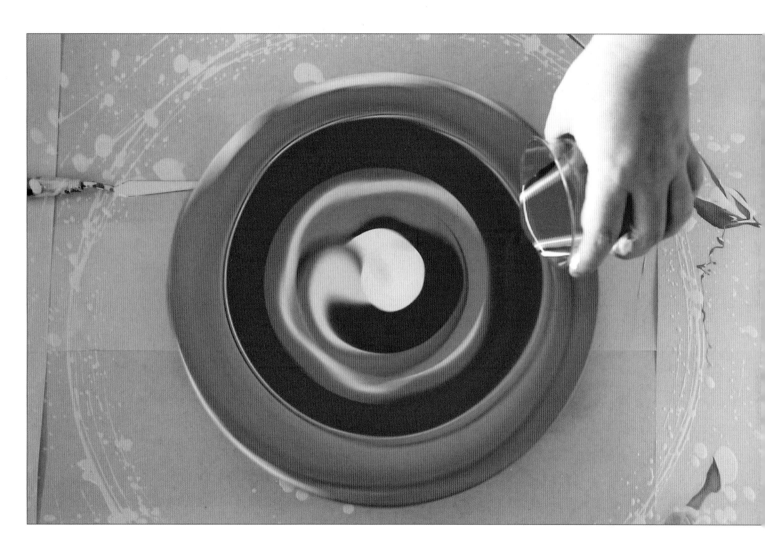

STEP 5
Now for the fun part! Spin your surface, and pour your paint as the surface spins.

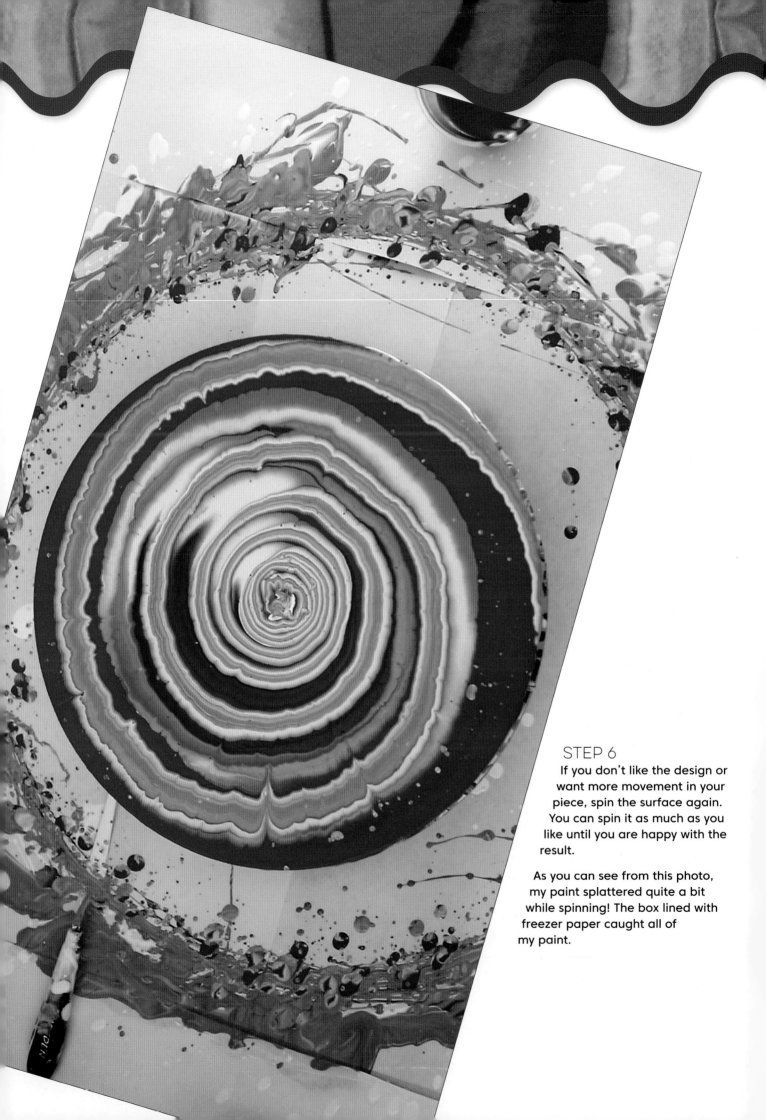

STEP 6

If you don't like the design or want more movement in your piece, spin the surface again. You can spin it as much as you like until you are happy with the result.

As you can see from this photo, my paint splattered quite a bit while spinning! The box lined with freezer paper caught all of my paint.

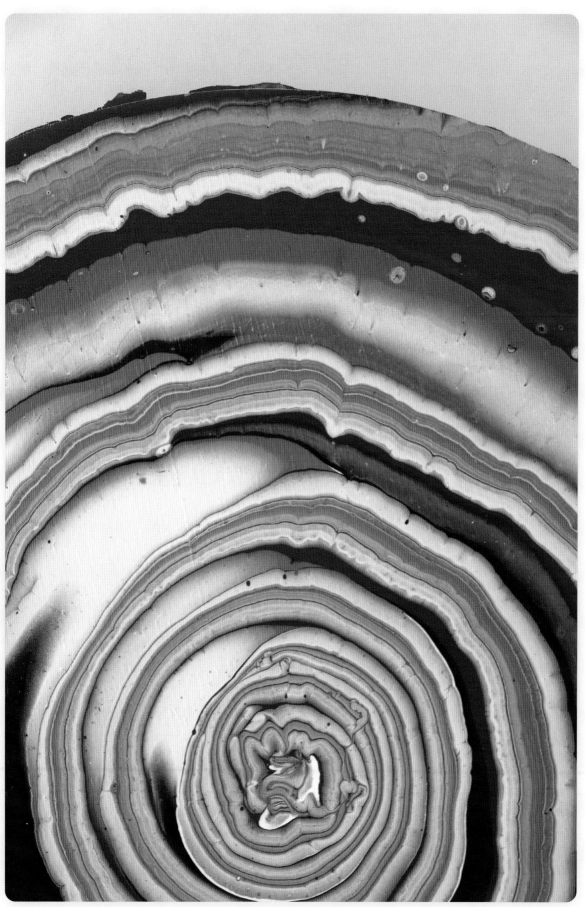

Sink-Strainer Pour

Pouring paint through a sink strainer is an awesome way to create a unique pattern on your canvas. For this technique, you can choose to do a dirty pour using all of your colors at one time, or you can pour individual colors through the strainer onto the canvas. There is a wide variety of sink strainers available in stores and online, and with so many styles, you can create all sorts of varied designs with this technique.

TOOLS & MATERIALS:
- Freezer paper
- Canvas
- Cups
- Paint
- Pouring medium (I used Elmer's® glue)
- Stir sticks
- Water
- Sink strainer (you can use more than one if you wish)

I WASN'T INTERESTED IN CREATING CELLS IN MY PIECE, SO I DIDN'T USE SILICONE OR A TORCH, BUT THAT IS ALWAYS AN OPTION!

STEP 1

I used various neon colors, as well as white for the background. Lay freezer paper flat on your working surface and place your canvas on cups so that the excess paint will run off.

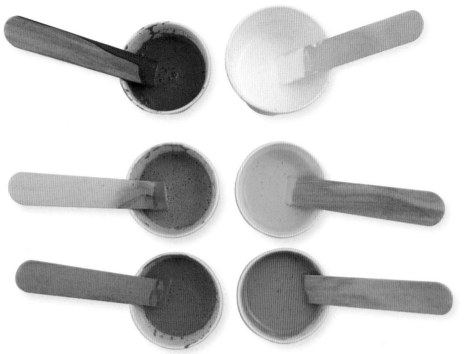

Mix your paint and pouring medium—about 2 parts glue to 1 part paint. Slowly add water and mix until you have the consistency you like for pouring. Glue and paint create a thicker mixture than pouring medium and paint, so it takes a little more water to get the pouring consistency right.

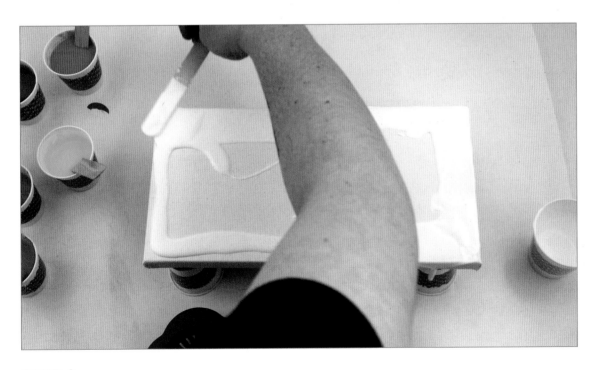

STEP 2

To help the colors move across the canvas more easily, start by putting down a layer of white paint on the canvas. You can use a stir stick, gloved hand, or palette knife to create good, even coverage.

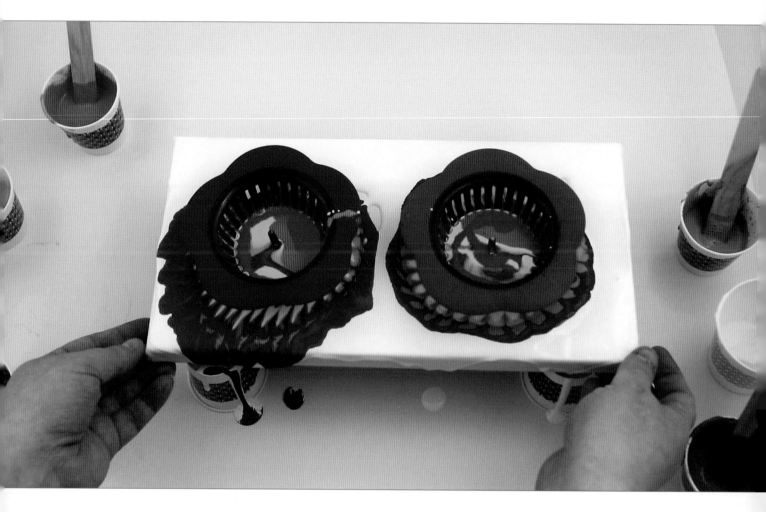

STEP 3

Place a sink strainer on the surface of the canvas. Since I worked on a rectangular canvas, I decided to use two strainers, one on each side of the canvas.

Pour your paint mixtures into a single cup and pour through the sink strainer onto the canvas as a dirty pour, or pour the colors individually through the sink strainer. A dirty pour will create a more blended pattern, while pouring the colors individually will maintain some separation of color on the canvas. I poured my colors individually through the strainer.

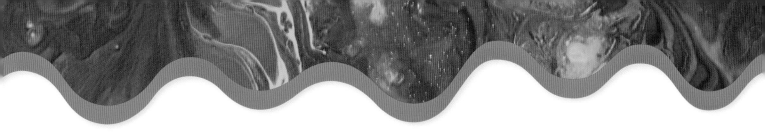

STEP 4

Remove the strainer(s) from the canvas. There may be excess paint on the strainer; place your hand or a paper towel underneath it so that the paint does not drip into your design as you move the strainer off of the canvas.

Now you can tilt the canvas to spread your paint and design. If you like your design as it is, set the canvas on a flat surface to dry.

STEP 5

I worried that the purple looked too dominant in my painting, so I placed both strainers back on the canvas, poured a few more colors, removed the strainers, and then tilted again. If you have enough paint mixed up, you can pour as much or as little as you want through the sink strainer until you like your design.

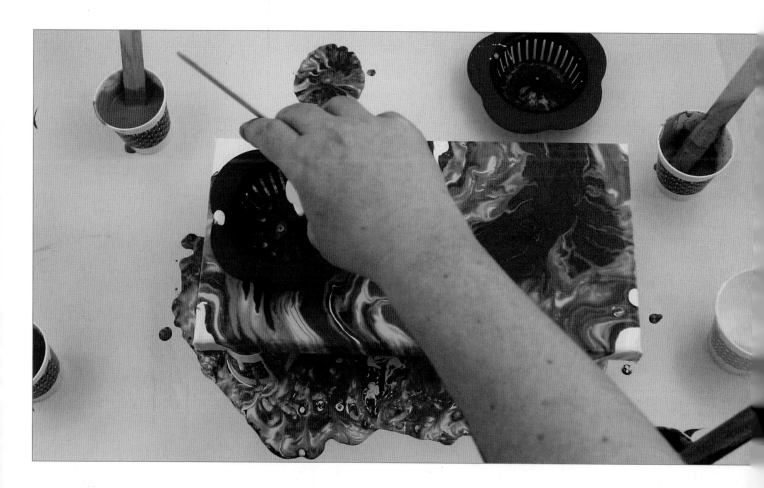

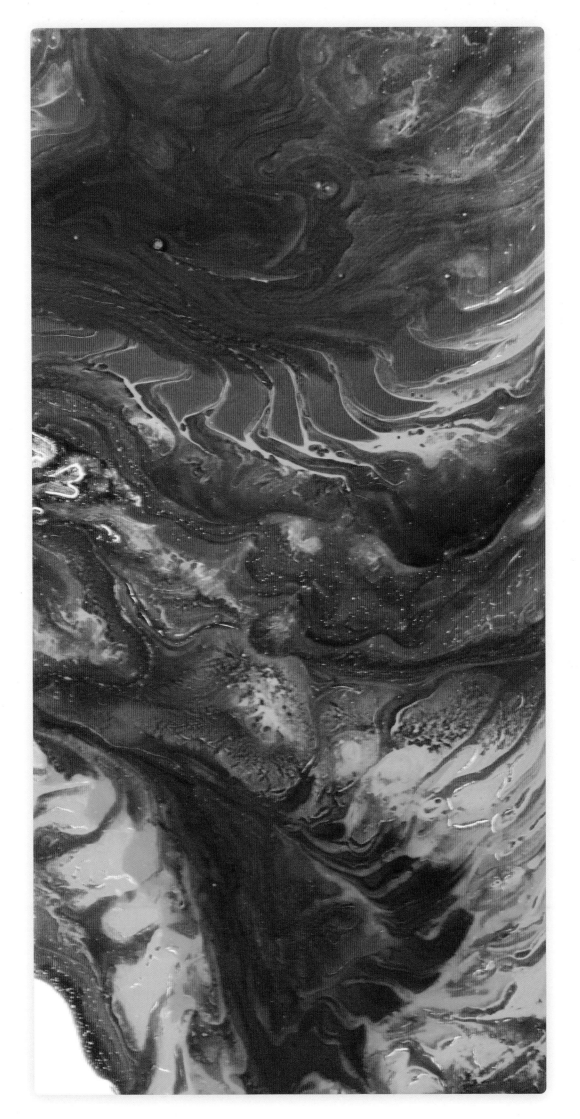

String Pull

The string pull is popular among fluid artists for creating beautiful abstract flowers. Using items like string or a necklace chain, you can create a more intentional design. You can dip the string in a single paint color or multiple colors to change up the final outcome!

TOOLS & MATERIALS:
- Paint
- Pouring medium (I used PVA glue)
- Cups
- Water
- Canvas
- Stir sticks
- Freezer paper
- String

I CHOSE NOT TO USE SILICONE OR A TORCH TO CREATE CELLS, BUT THAT'S ALWAYS AN OPTION FOR YOUR OWN ART!

STEP 1

I used black for my background and metallic blue and bright rose gold for my string pull.

Prepare your paint mixtures following a ratio of about 2 parts pouring medium to 1 part paint. You will want to keep these paint mixtures slightly thicker than usual so that the abstract flowers hold their shape. If the paint is too thin, your pulled color(s) may sink into the background color.

Place your canvas on cups to allow excess paint to drip off. Prepare your working surface.

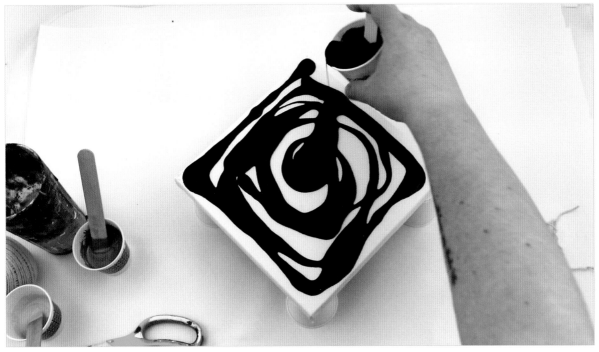

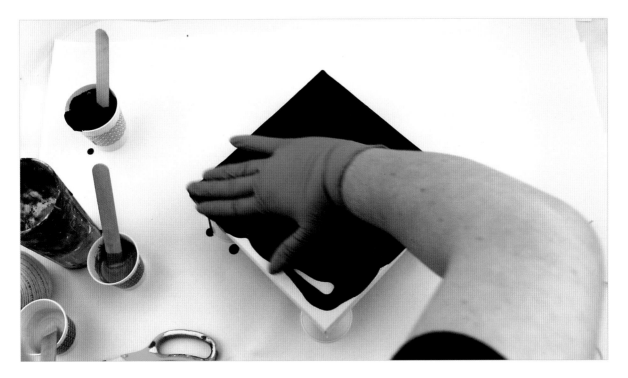

STEP 2

Begin by pouring your background color. You can tilt the canvas or use a stir stick or palette knife to spread the paint. For this technique, I like to use a gloved hand to spread the paint. I do this so that I can feel how much paint is on the canvas. As with your paint mixtures, if you use too much paint for your base coat, your pulled color may sink into it and you will lose your top color.

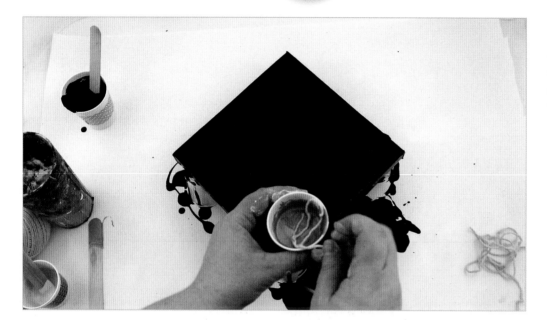

STEP 3
Use one color at a time for your string pull. Dip the string in your first color, and use a stir stick to ensure that the string is covered in paint.

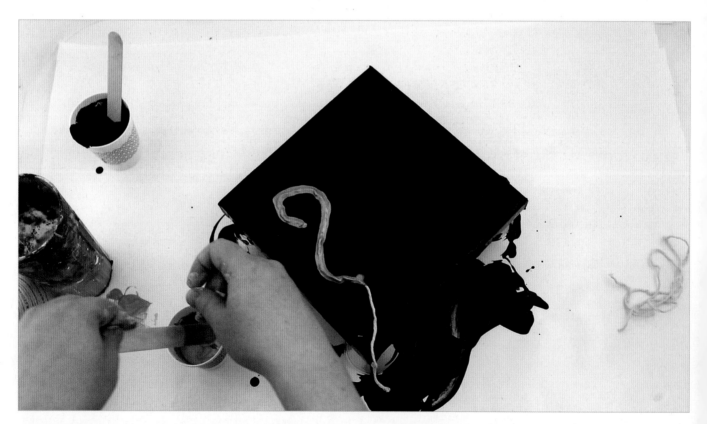

STEP 4
Remove the string from the cup of paint and gently place it on the canvas. I placed my string in an "S" shape. Then repeat steps 3 and 4 as many times as you like with your first color.

Note: I chose to place multiple strings on my canvas, but you can use a single string and pull it off to use again if you prefer.

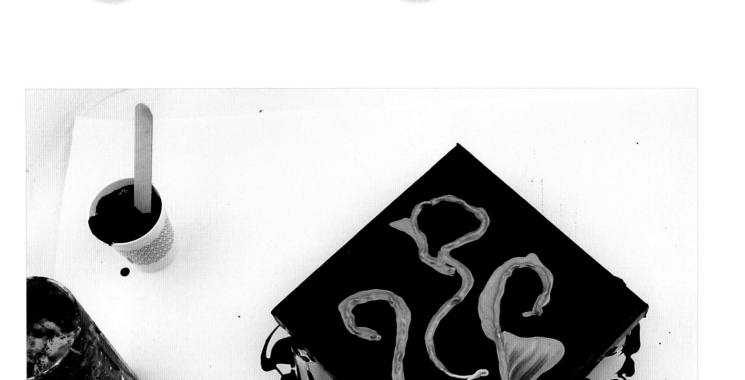

STEP 5

Once your paint-covered strings are on the canvas, pull the string straight down off the canvas. I pulled my strings off in a straight line, and because I placed them in "S" shapes, the curved portions created an abstract petal shape.

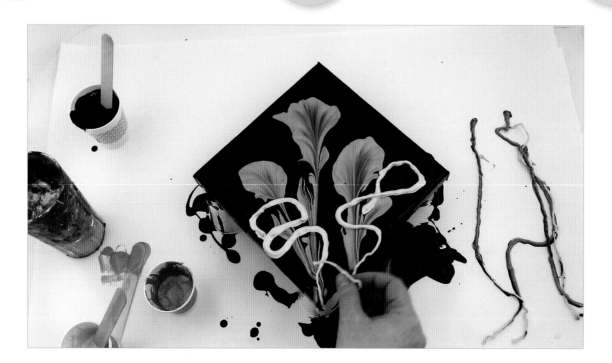

STEP 6

With one color down, repeat steps 3-5 with your second color. I placed my blue strings slightly lower than the rose-gold strings to create a layered effect with the flowers.

Repeat steps 3-5 as many times as you like. I did one more layer of rose-gold strings and then stopped.

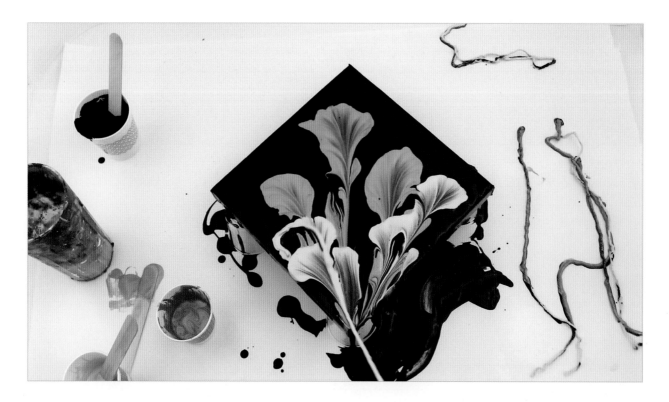

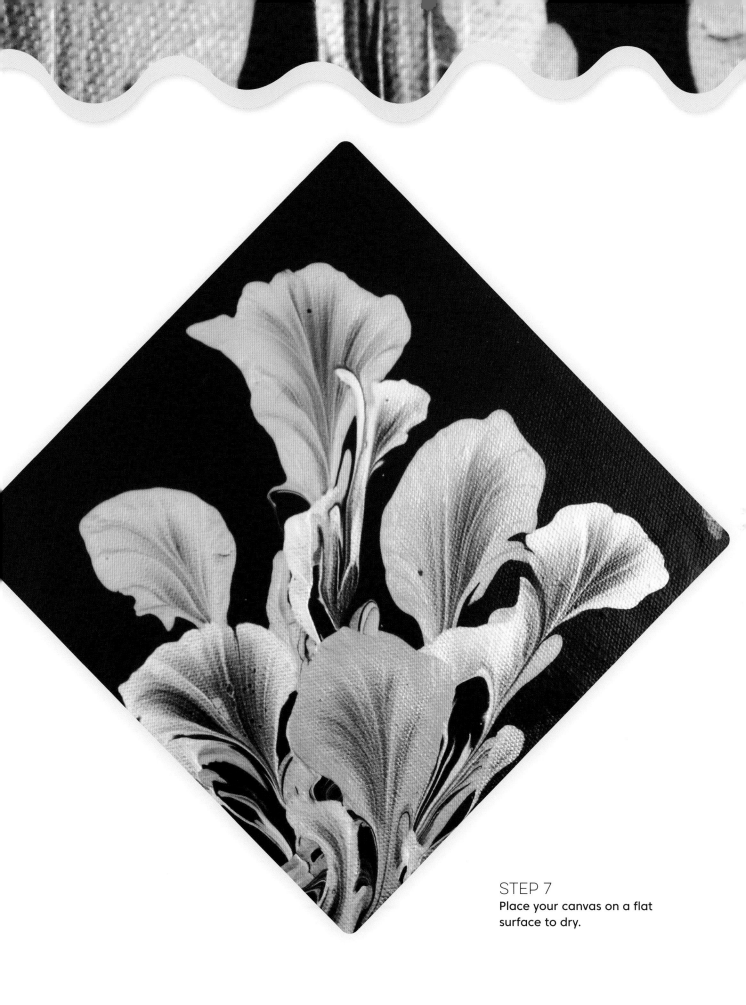

STEP 7
Place your canvas on a flat surface to dry.

VARIATION: FEATHER STRING PULL

A variation on the string-pull technique, the feather string pull is a method of string pulling that intentionally creates a featherlike design.

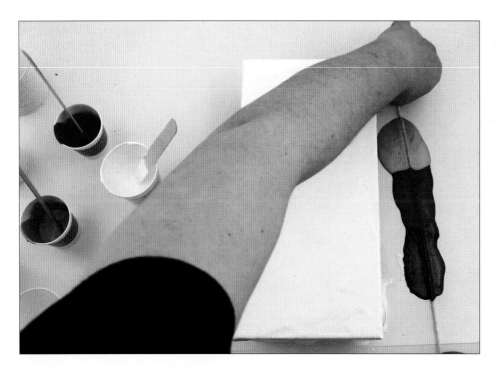

STEP 1

Begin this technique the same way you did for the string pull on page 94, and incorporate water until the mixture has the right consistency for pouring. Cut a piece of string about the same length as the canvas. Then spread white paint on the canvas. Instead of dipping the string into a cup of paint, place the string on the table and pour each of the colors on the string. Gently roll the string through the paint to make sure it's completely covered.

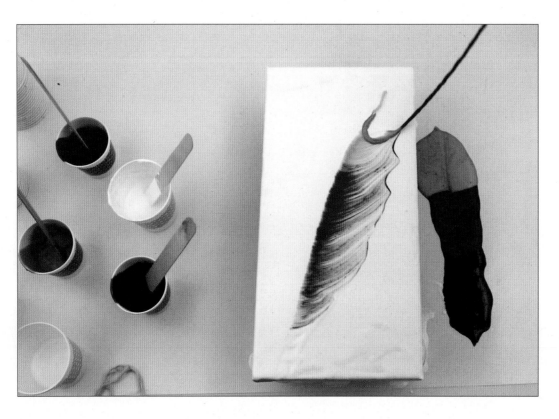

STEP 2

Carefully pick up the string and place it on the canvas. Then grab the end of the string and gently pull it, moving both out and up to pull the colors through the base paint and create the first half of your feather.

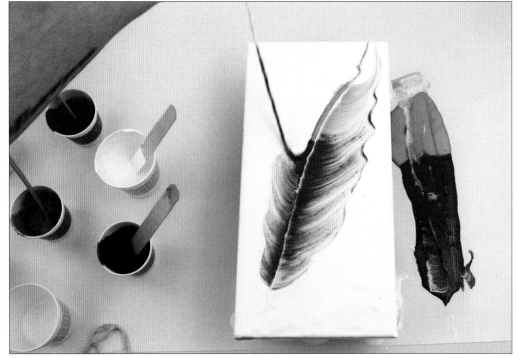

STEP 3

If you have too much white paint on the string, use a second string, or wipe off the string. Then place the string in the paint, again ensuring that the string is covered with all of the paint colors.

Gently place the string next to the first pull. Grab the end of the string and pull, this time moving in the opposite direction.

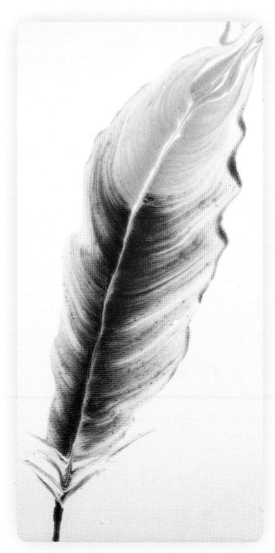

Negative Space

The negative-space pour is easy to learn. Use one color for your base coat, and then pour a variety of other colors on your canvas while leaving large portions of the background untouched. I enjoy this technique because the poured colors really "pop" against white or black, but you can also mix it up and use other colors, like indigo or turquoise, for the background.

TOOLS & MATERIALS:
- Paint
- Pouring medium (I used DecoArt®)
- Water
- Cups
- Stir sticks
- Freezer paper
- Wood surface

Optional tools for creating cells:
- Liquid silicone
- Torch

STEP 1

I used a color palette of blue, white, pewter, and metallic brown. Prepare your paint by mixing about 2 parts pouring medium to 1 part paint; then incorporate water until you have the consistency you like for pouring.

Prepare your working surface.

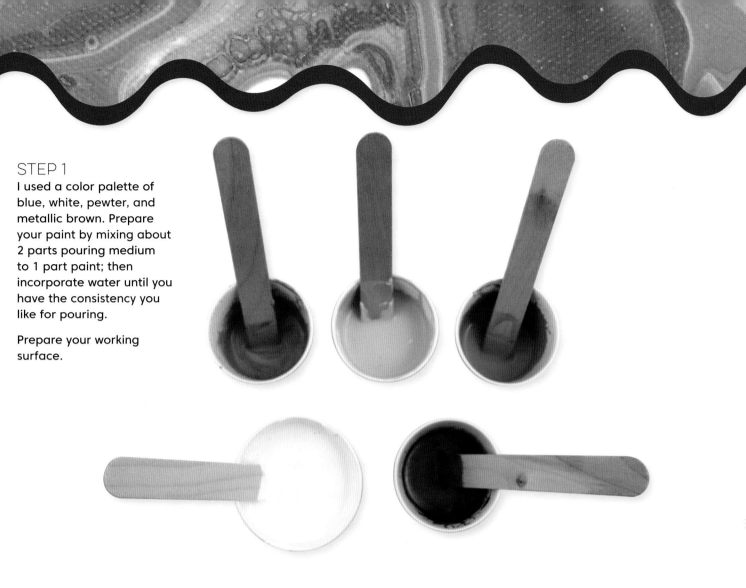

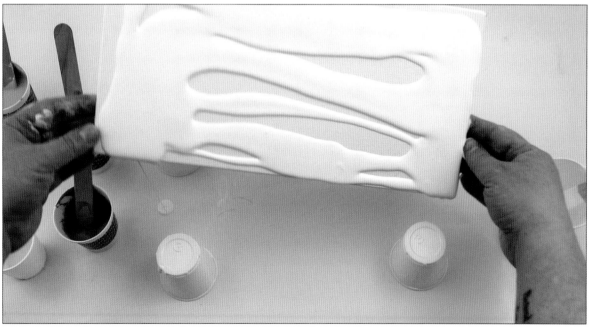

STEP 2

Pour white paint on the canvas for the base coat/background. You can tilt your canvas to evenly spread the paint or use a stir stick or palette knife.

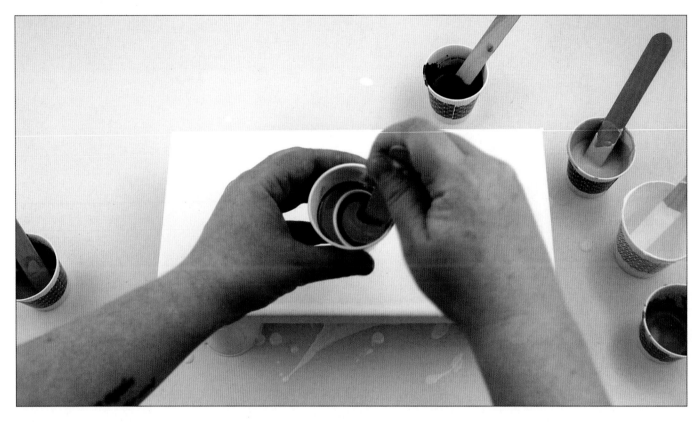

STEP 3

This technique allows you to pour your colors any way you want. I decided to do a dirty pour and layered all of my colors in one cup. Once I had my paint in the cup, I swirled a stir stick once to gently mix the colors. This helps break up and blend the colors when poured onto the canvas.

AVOID OVERMIXING THE PAINT OR YOUR POURED ARTWORK WILL LOOK MUDDY IN COLOR!

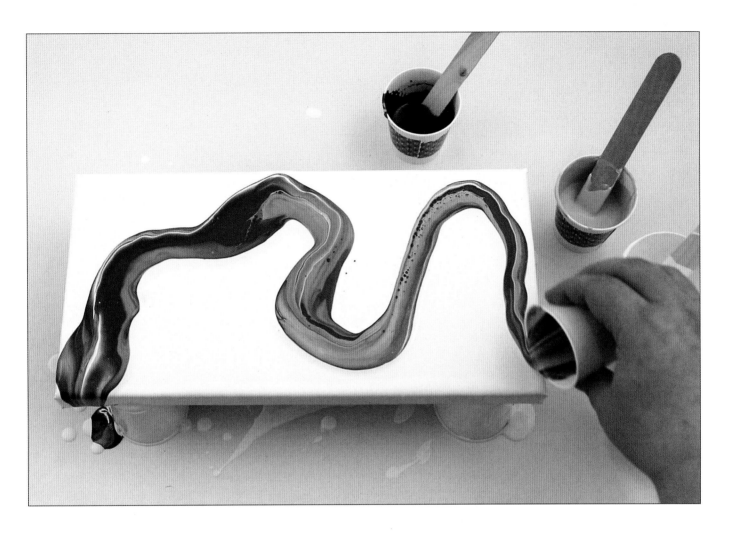

STEP 4

Now pour your paint onto the canvas! I moved in an "S" shape. You can see the metallic colors dominate but still contrast nicely with the white background.

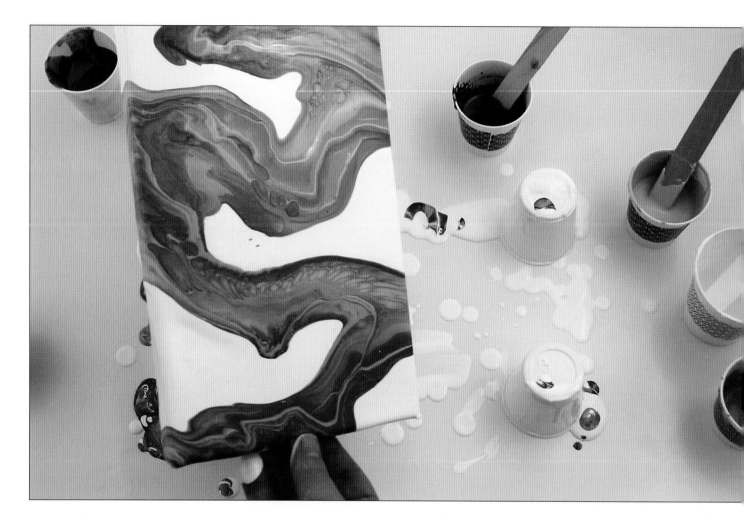

STEP 5

After pouring your paint, you can tilt your canvas any way you like to move the paint. Once you are happy with your design, place your canvas on a flat surface to dry.

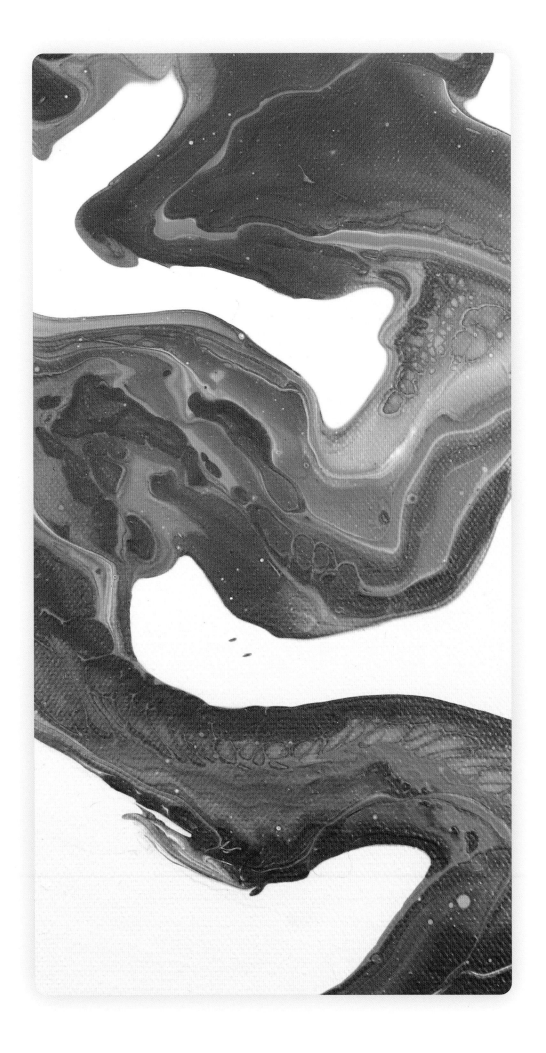

Swipe

This technique is a favorite among artists. Using silicone in one or a few colors and then swiping another color over the others will create an explosion of cells in your artwork!

TOOLS & MATERIALS:
- Paint
- Pouring medium (I used Floetrol®)
- Water
- Stir sticks
- Cups
- Freezer paper
- Canvas
- Paper towel for swiping

Optional tools for creating cells:
- Liquid silicone
- Torch

STEP 1

For this painting, I used indigo, turquoise, and pewter. I planned to swipe the pewter over the indigo and turquoise to create beautiful cells. Mix the paint with your pouring medium at a ratio of about 1 part paint to 2 parts pouring medium. To keep the paint mixtures thicker and hold the cells, add less water than you normally would for pouring.

If you are using silicone, gently incorporate it now. You only need one or two drops. I used silicone only in the pewter.

Prepare your working surface.

STEP 2

Dampen your paper towel with water. I find that a damp paper towel helps create cells in my swipes, but you can also work with a dry swiping tool or use another tool, such as a palette knife, piece of paper, silicone baking mat, or spatula.

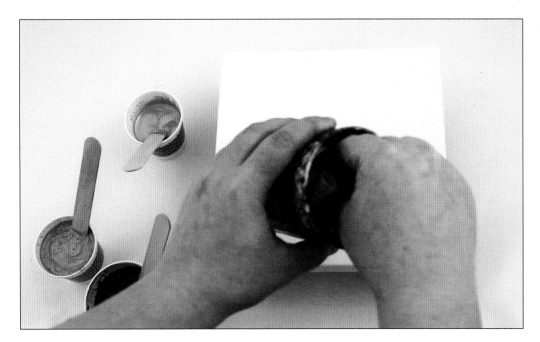

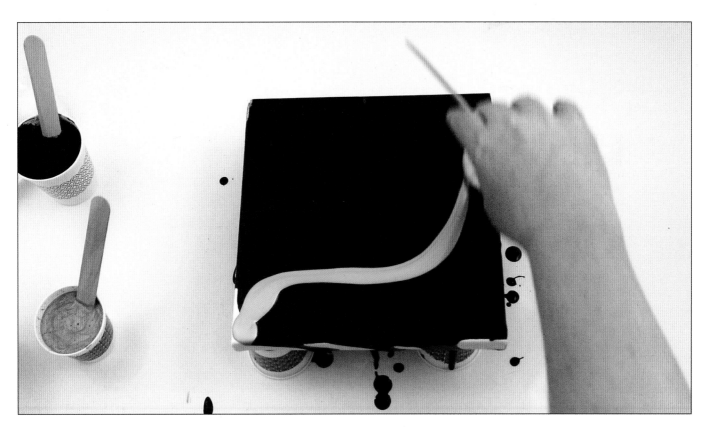

STEP 3

Begin pouring paint on the canvas in any pattern and amount you like.

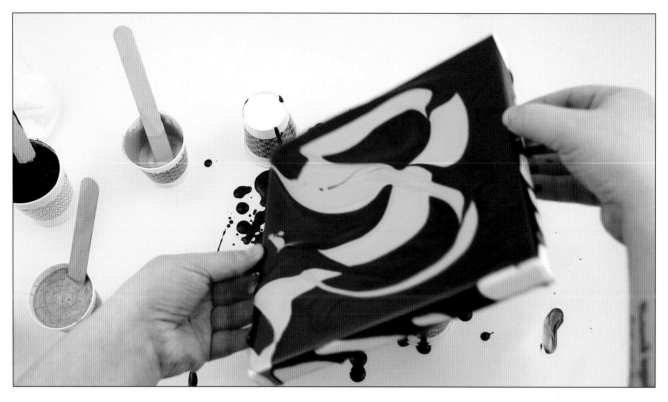

STEP 4
With the paint colors poured, tilt the canvas to spread the paint and ensure even coverage on the canvas.

Then pour more paint at the top of the canvas. I used pewter.

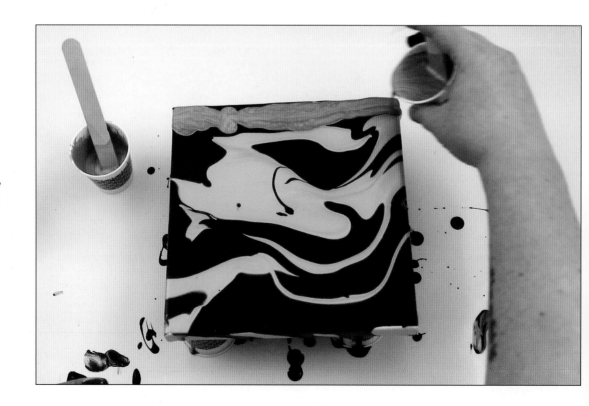

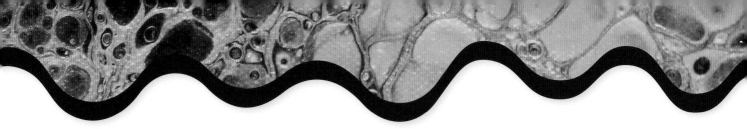

STEP 5

Carefully place the swiping tool on the top area of paint (in my case, the pewter). Make sure that the paper towel or other swiping tool touches the paint and that there are no air bubbles. Then swipe in a downward motion, pulling the top area of paint across the other colors.

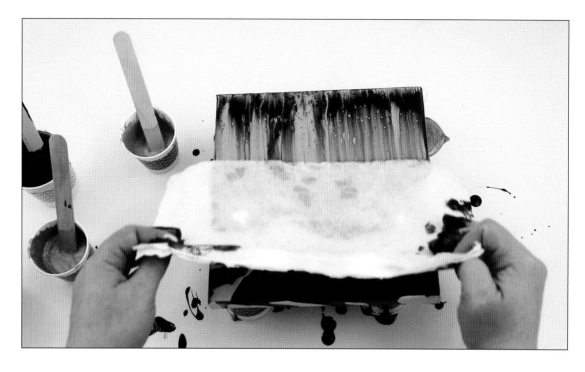

STEP 6

If you want to apply a torch to your piece, do so now. I did not torch mine; instead, I let it sit for a minute. I wanted to remove some of the pewter, so after my painting rested for a bit and cells began to form, I tilted the canvas to pull and enlarge the cells, as well as to remove some of the pewter from the top.

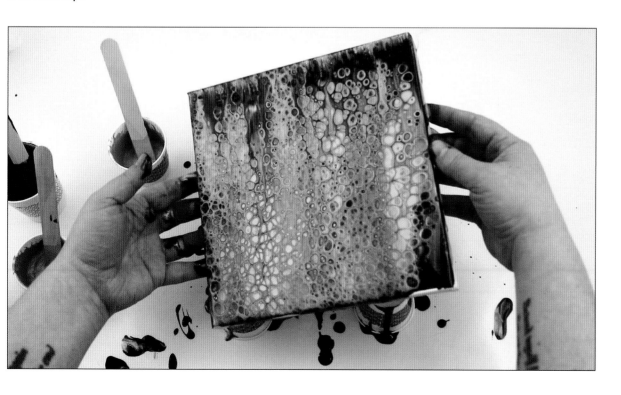

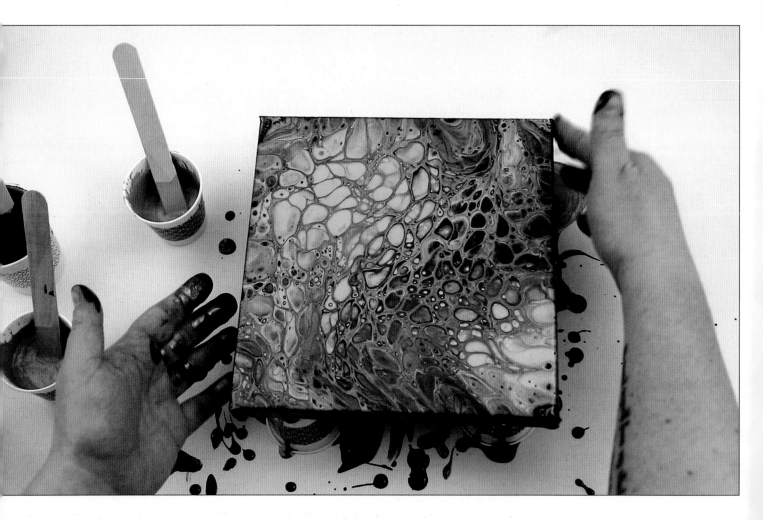

STEP 7

If there are bare areas of canvas, such as on the sides and corners, use leftover paint to cover them up. Once you are happy with your design, place your canvas on a flat surface to dry.

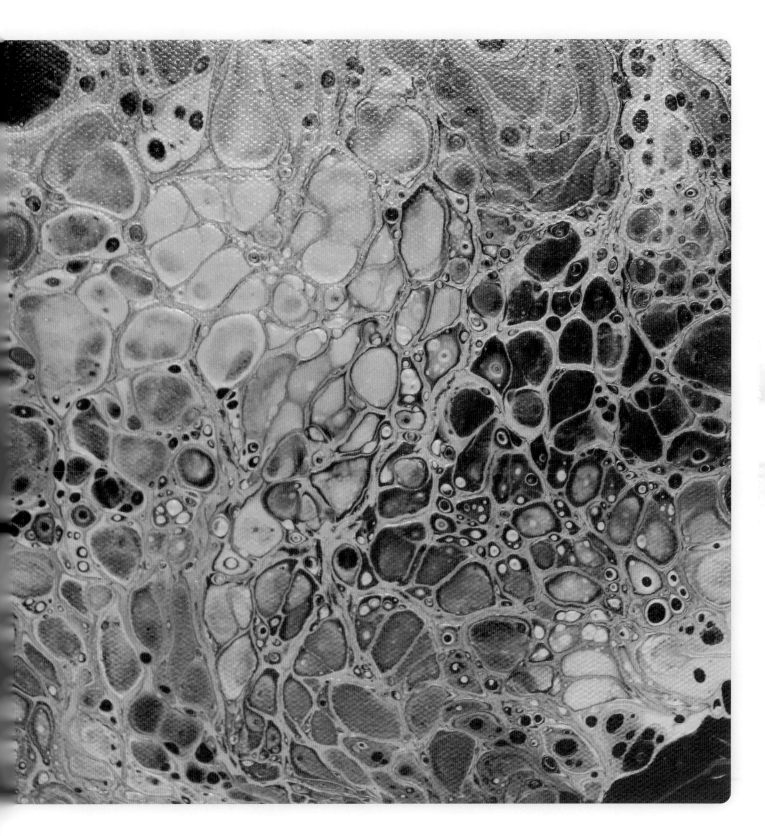

Embellishing Art

Adding embellishments is a great way to give your art that extra pop of flair. Some options for embellishments include sand and shells to create an ocean-inspired piece; stones, glass shards, or crystals for a geode piece; and gold leaf or alcohol inks to add definition between sections of color. Your poured painting can even be used as the background for a stencil or silhouette design. Embellishments can be added while a painting is wet or dry.

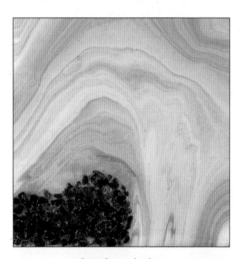

Geode painting

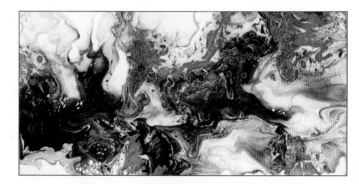

Alcohol ink

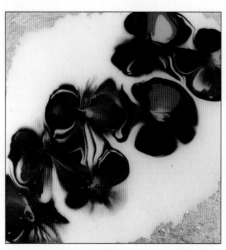

Gold leaf

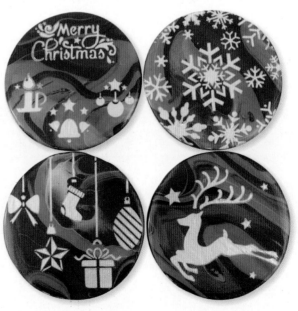

Stenciled coasters

BEFORE EMBELLISHING YOUR ART, MAKE SURE YOU'VE CLEANED OFF ANY ADDITIVES, SUCH AS SILICONE (SEE PAGES 29-30).

GOLD ALCOHOL INK

This project uses the straw-blown painting on pages 58-61 and gold ink to create metallic stems that contrast with the colors of the tulips.

Rest your piece on a flat surface or table. You can use alcohol ink straight from the bottle for a bold, vibrant concentration of color, or thin it down slightly with about 1 tsp. rubbing alcohol.

Use a paintbrush to apply the alcohol ink and create thins stems, as well as layers of petals around some parts of the flowers.

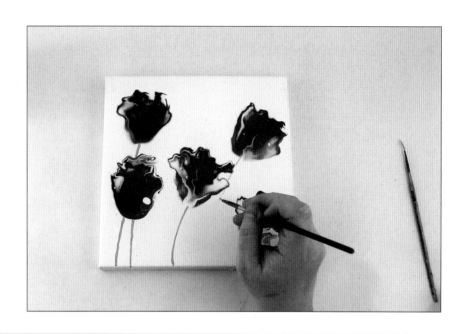

Let the ink dry and use rubbing alcohol to remove excess ink from the paintbrush. Letting the brush dry with ink on it will ruin the brush.

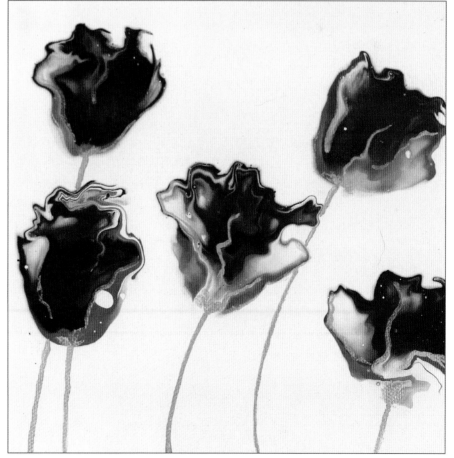

SILHOUETTE

Rest your painting on a flat surface or table. With a silhouette painting, you can choose any design you like. Since my background looks like water, I printed out some simple dolphin shapes to trace onto my canvas, but you could also use people, other animals, mountains, or trees.

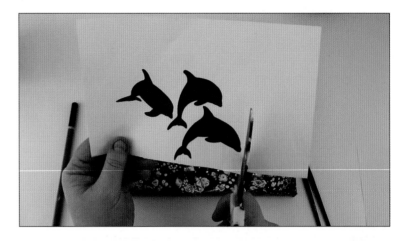

Draw your silhouette(s) over your painting. Then use black paint and a paintbrush to fill in the shape(s).

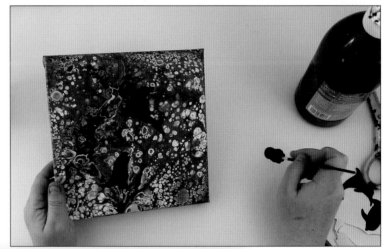

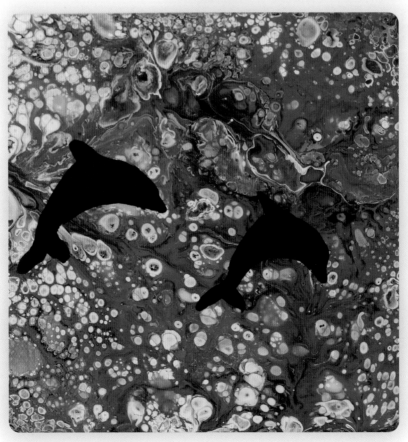

STENCIL DESIGNS

For this piece, I used a mandala stencil, heavy-body paint, and a palette knife to create a design over my painting.

Place the painting on a table or flat surface, and lay the stencil on the painting. Tape it down so that it won't move; then paint over the stencil.

Gently remove the stencil from the canvas.

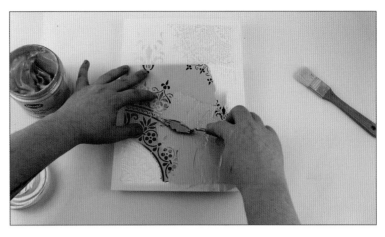

THE THICK TEXTURE OF HEAVY-BODY PAINT WILL RETAIN THE SHAPE AND DESIGN OF A STENCIL.

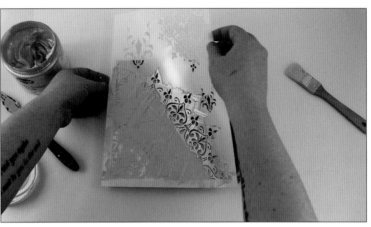

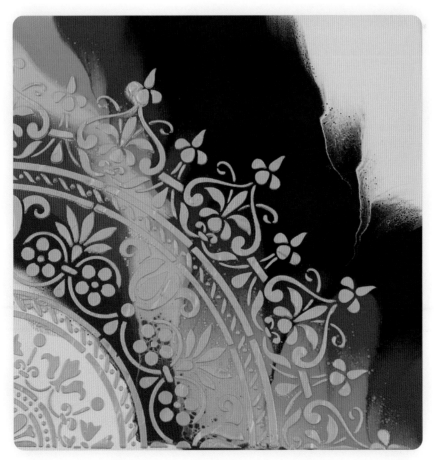

Jewelry & Bookmarks

Almost every time I make a painting, I use any leftover paint to create acrylic skins for other projects. This is a great way to save paint and avoid wasting it. You can make so many different things. I like to create necklaces, bracelets, earrings, hair clips, shawl pins, bookmarks, and magnets from my acrylic skins. If you use blank pendant trays, the possibilities are endless.

TOOLS & MATERIALS:
- Glass cabochons
- Pendant trays
- Jewelry glue
- Clear craft adhesive glue
- Acrylic skins
- Scissors

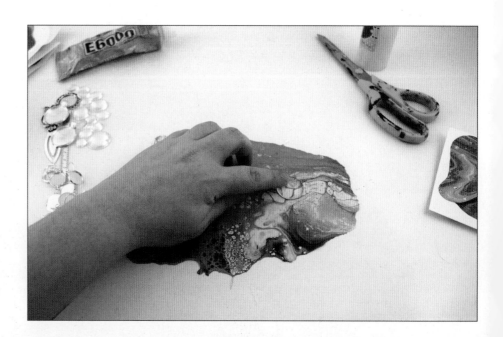

STEP 1

There are two ways to begin this process. You can cut a shape from your acrylic skin and glue it to the glass or glue the glass to the skin and then cut around the shape once dry. I prefer the latter method.

Before gluing the glass piece, place the cabochons on the acrylic skin and move them around to find the section of acrylic skin you want to use. If you're making matching earrings, for example, try to find similar-looking areas of the acrylic skin.

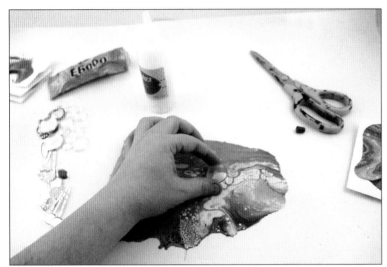

STEP 2

Add a small amount of glue to the acrylic skin and place the glass dome on the glue. Press on the dome and hold it in place for 15 to 30 seconds.

STEP 3

Let your pieces dry for at least 24 hours. Once dry, cut the glass piece from the acrylic skin. Before gluing this piece into the pendant tray, place it in the tray first to make sure it fits. Then add glue to the pendant tray or on the back of the glass piece, and rest it in the pendant tray. Press firmly to adhere. If you've used too much glue and it pours out around the edges of the piece, use tissue or paper towel to wipe off any excess.

STEP 4

Let the piece dry for at least 24 hours.

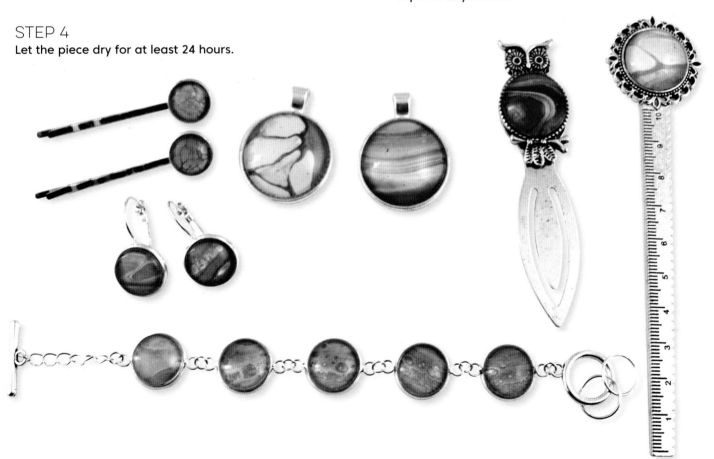

Coasters

While I enjoy painting larger pieces, coasters are my favorite thing to make. They are small but still allow for awesome details, and each one makes its own individual painting.

I use wood circles, squares, and hexagons to make coasters. Wood shapes are sold in craft and home-improvement stores, but if you can't find the shape you want, look online. Home-improvement stores also carry ceramic tiles that are great for painting on and finishing as a coaster.

TOOLS & MATERIALS:
- Wood circles or squares
- Leftover paint from a previous project, or create a new mixture
- Cups
- Stir sticks
- Tape
- Scissors
- Gloves
- Respirator
- Torch
- Cork or felt
- Resin, varnish, or waterproof sealant

Optional tools for creating cells:
- Liquid silicone or dimethicone
- Torch

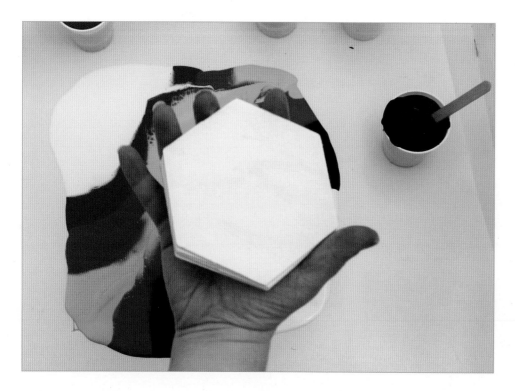

STEP 1
I like to mix up extra paint so that I can use the leftovers in other projects. For these coasters, I used the paint I poured for the dip project on pages 64-69.

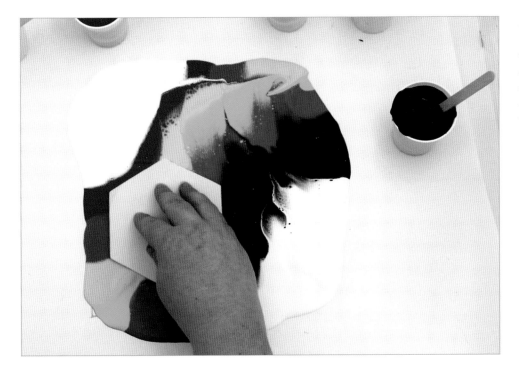

STEP 2

If you plan to pour paint onto the coasters, place each coaster on a cup to allow excess paint to drip from it. I dipped my coasters directly in the leftover paint.

TO KEEP THE WOOD PIECES FROM WARPING, YOU CAN GESSO OR PRIME THEM FIRST.

STEP 3

Dip each coaster in paint, using a different area of the poured paint for each coaster. This will keep the coasters from looking muddy from the previous dip.

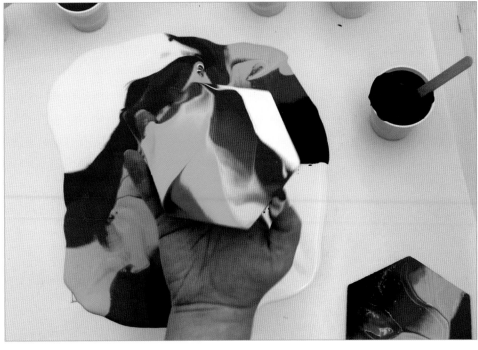

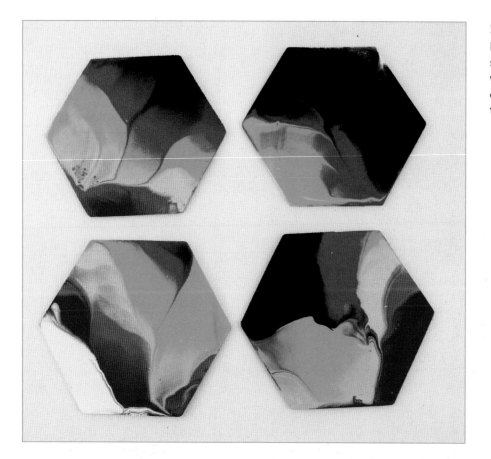

STEP 4

Lay the coasters on a flat surface to dry for a couple of weeks. If you add resin too soon after painting, moisture can turn the resin cloudy.

STEP 5

Apply tape to the back of each coaster so that you can easily remove the resin after curing.

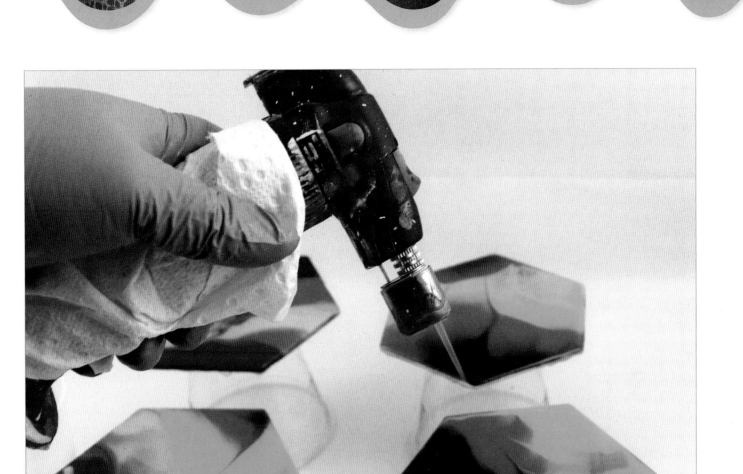

STEP 6

Lay freezer paper over your working surface; then place the coasters on cups. Read the instructions on the resin to learn how to mix it, and follow all safety precautions, such as wearing gloves and a respirator.

Pour the resin onto the coasters. Tilt each coaster and/or use a gloved hand or stir stick to spread the resin evenly over the coaster, including the sides. You may need two or three layers of resin. Wait 12 hours between each coat.

Then gently torch each coaster to remove air bubbles.

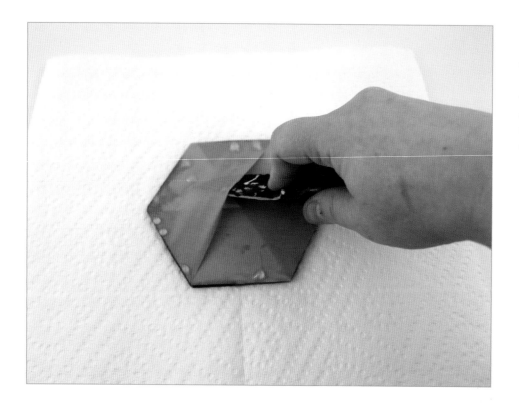

STEP 7

Resin takes about 72 hours to cure, but to make sure it hardens, wait a week before finishing the back of each coaster. Remove the tape and resin drips from the back of each coaster.

STEP 8

I used cork to finish the back of each coaster, but felt would work too. The cork I purchased comes with adhesive backing; remove the adhesive and place it on the coaster. If your felt or cork does not come with adhesive, use glue to adhere it to the back of the coasters.

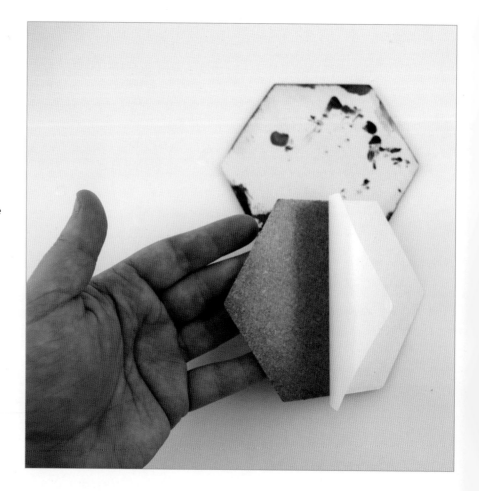

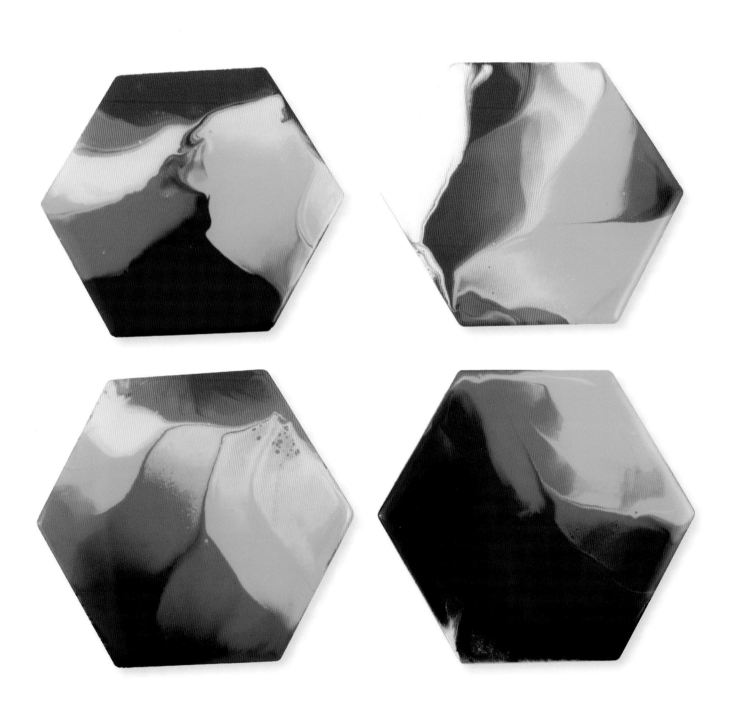

Inspiration Gallery

Here are some other projects you can create using paint pouring!

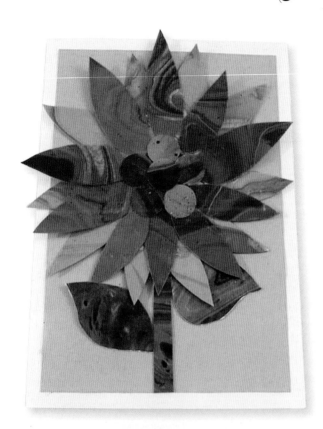

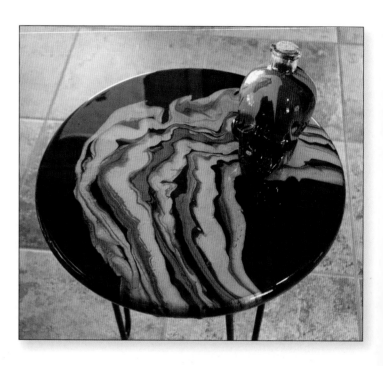

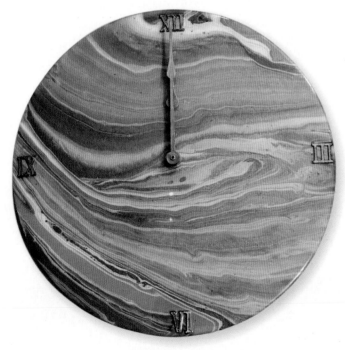

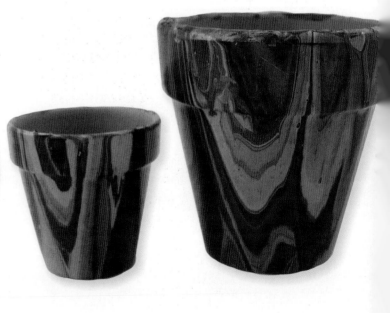

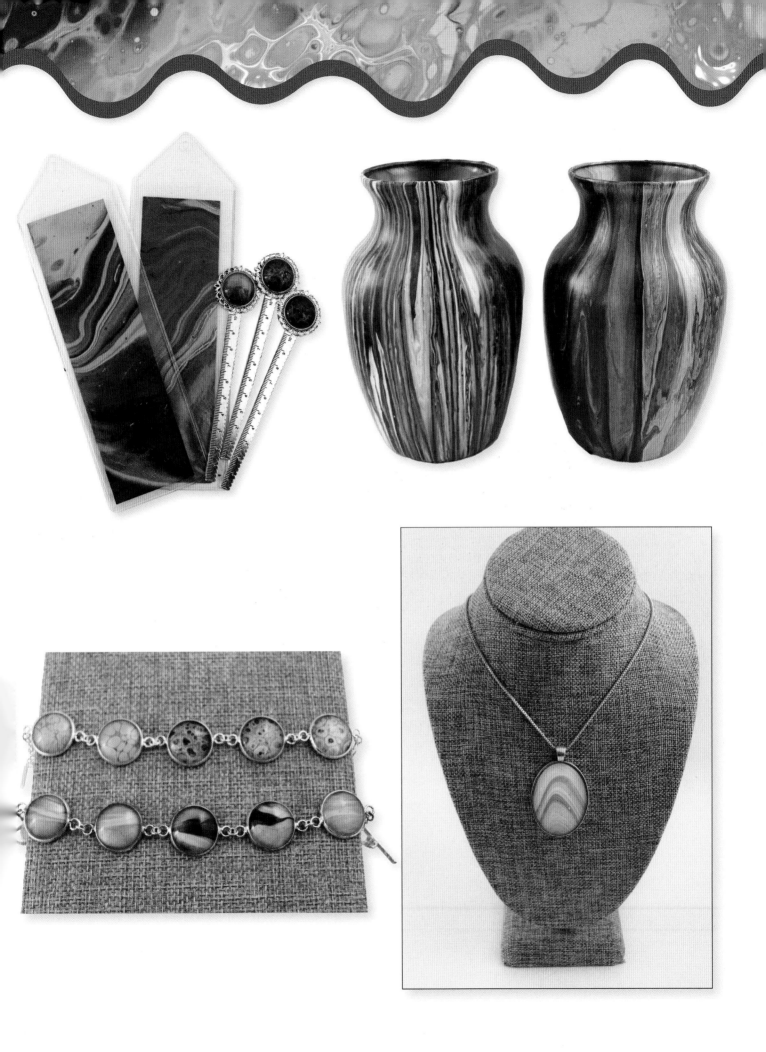

About the Artist

Amanda VanEver is a self-taught artist and librarian in Dayton, NV. She enjoys the versatility of acrylic paint and the vast array of techniques that can be used with fluid art.

Amanda credits her abilities to the artists willing to share their tricks, tips, and techniques for different styles of fluid acrylic painting. She learned to create poured art using Facebook groups and YouTube videos.

Every week, Amanda films her processes and answers questions on her YouTube channel @Amanda's Designs. She sells her artwork locally in Carson City, NV, as well as through her Etsy shop, Amanda's Doodles.

Also available from Walter Foster Publishing

978-1-63322-737-8

978-1-63322-610-4

978-1-63322-793-4

Visit www.WalterFoster.com